IMAGES
of America

ELEANOR ROOSEVELT
A HUDSON VALLEY REMEMBRANCE

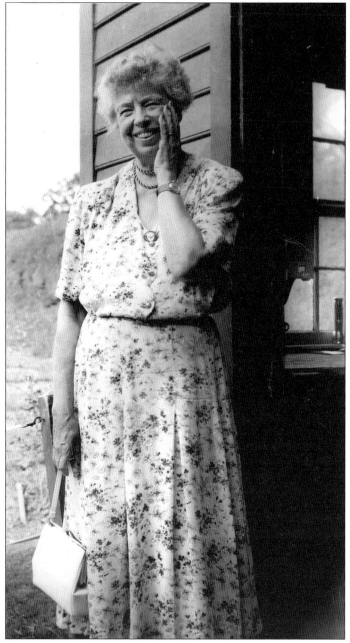

OH, WHAT A PLEASANT SURPRISE! Eleanor Roosevelt would have been surprised and no doubt pleased to learn how she is remembered. Although her entire life was testimony to service on behalf of others, she expected no gratitude. She found joy in a child's smile and the knowledge of a job well done. This is her story as a daughter of the Hudson Valley. This is also the story of her friends, relatives, acquaintances, and those whose lives she touched, unwittingly at times, by her words and her work. Admirers of Eleanor Roosevelt of all ages and political and economic backgrounds came together to create a memorial to her, which would have brought a smile to her face and the hand of wonder to her cheek. They are following in her footsteps, starting from her favorite place, Val-Kill, in the heart of the Hudson Valley. (FDRL.)

IMAGES
of America

ELEANOR ROOSEVELT
A HUDSON VALLEY REMEMBRANCE

Joyce C. Ghee and Joan Spence

ARCADIA

Published by Arcadia Publishing
Charleston SC, Chicago IL, Portsmouth NH, San Francisco CA

Printed in Great Britain

Library of Congress Catalog Card Number: 2005924385

For all general information contact Arcadia Publishing at:
Telephone 843-853-2070
Fax 843-853-0044
E-mail sales@arcadiapublishing.com
For customer service and orders:
Toll-Free 1-888-313-2665

Visit us on the Internet at http://www.arcadiapublishing.com

CONTENTS

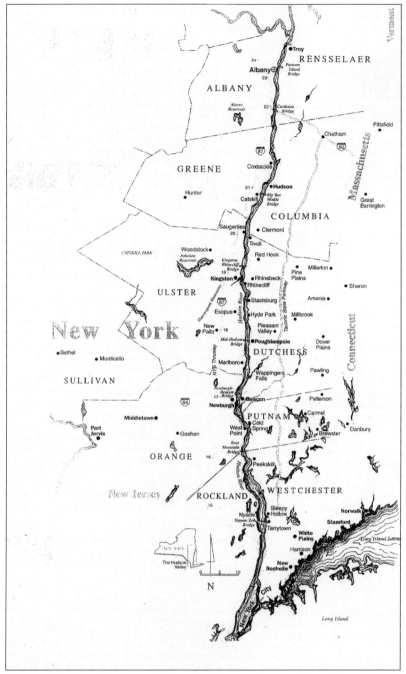

A Map of the Hudson Valley. Although Eleanor Roosevelt's wide-ranging and caring concern made her seem a citizen of the world, her heart always drew her back to the Hudson Valley. Often spoken of as America's Rhine, because of its beauty, history and legendary past, the valley, from New York City to mountains beyond Albany, belonged to the "river families." As artist Olin Dows, another river family member, said: "the Hudson community has a long tradition. It gives people roots . . . and Mrs. Roosevelt had roots. It gives stability to character, whether a president or a gardener . . . the Hudson is just ours." (PJ.)

INTRODUCTION

Eleanor Roosevelt was shaped by parentage, upbringing, environment, and events. The Hudson Valley played a major role in molding the character of a woman whose life is legend and whose death brought together mourners from around the world.

This book recounts her history in this valley during her lifetime, from the end of the 19th century to the mid-20th century, as prelude to her continuing impact on our lives today. The valley, a culturally rich region linking metropolitan New York City to Albany, is defined by the beautiful Hudson River and its role in national history. Eleanor Roosevelt's roots were here in a society composed of related families and those of similar backgrounds, bound by common interests and marriage. This was in fact feudal territory where those who had early acquired land remained firmly in charge of the political, social, and economic life of the area.

But Eleanor Roosevelt also came to know people who themselves or whose families had more recently immigrated to the valley. Labor and civil rights leaders, like neighbors and local business owners, became her friends. She touched many individuals quietly or in episodes that became memorable highlights of their lives. She was embraced by residents from Yonkers to Newburgh, from Poughkeepsie to Ellenville and Kingston, in places large and small. She seemed to be everywhere and always accessible.

After Pres. Franklin D. Roosevelt's death, when she could have lived anywhere in the world, Eleanor Roosevelt chose to make her home in a simple cottage along a stream at Val-Kill, near the Hyde Park hamlet in Dutchess County. It was her unique capacity to live both in the world of landed gentry and in the everyday world of ordinary citizens that made her welcome wherever she went.

Memories of her life and influence in the Hudson Valley are shared here by family, friends, colleagues, and acquaintances. Her transformation from shy debutante and young society matron into the "First Lady of the World" is an integral part of the story. She had the exceptional ability to act as easily on the international scene as on the local level. She remarked that it was usually the problem of a single person that first aroused her interest. It then widened to the community, the nation, the world. For her, problems were not intellectual abstractions; they were encountered by real people needing practical solutions. Her emphasis was always on how to help the person, on how she could be of use.

As important as the solutions was the process itself. Never patronizing and always honest and friendly, whether at a session of the Human Rights Commission or a local meeting, Eleanor Roosevelt listened carefully, asked questions, involved those with the problem in trying to find the solution, reached out to those who could help, and worked hard to reach a settlement. Her

total lack of self-importance contributed to her success. This was the model used by those who, 13 years after her death, began the efforts that resulted in the establishment of the Eleanor Roosevelt National Historic Site, where the Eleanor Roosevelt's Center at Val-Kill addresses today's problems.

The first chapter explores Eleanor Roosevelt's roots in the Hudson Valley: the family and society into which she was born and later married. Livingstons, Chanlers, Newbolds, and Morgans were all part of a Hudson Valley society that entered the beginning of the 20th century with optimism, enthusiasm, and a sense of its own powers.

The second chapter deals with the time from her marriage to Franklin Roosevelt in 1905 to his death in 1945: life in Hyde Park at Springwood and at Val-Kill, becoming a political activist and teacher in New York City, the period as New York's First Lady, and then as wife and emissary of a president determined to promote New Deal programs and to safeguard democracy. It will highlight a lifelong focus on issues important to her, including education, civil rights, personal responsibility, and the democratic process.

After the president's death in 1945, Eleanor Roosevelt decided to make her home at Val-Kill. This connected her intimately and freely to the community. Throughout the next 17 years, she returned there from exhaustive duties and world travel to rest and enjoy a simpler, if equally demanding, life. Here, she personally arranged flowers for the constant stream of guests. She enjoyed walking its fields with her dog, Fala, and his successors and growing her own vegetables. While she entertained world leaders, she also had time to take grandchildren to the Dutchess County Fair and to host card parties for neighbors. And, as always, she responded to those seeking help. Chapter Three concludes with her death in 1962.

The fourth and fifth chapters show how a diverse group, united by its belief in the importance of Eleanor Roosevelt as a role model for the future, succeeded in the passage of legislation establishing the Eleanor Roosevelt National Historic Site. Here, the Eleanor Roosevelt Center at Val-Kill arranges and sponsors programs on issues that were of concern to her and that continue to touch our lives today.

Authors' note: Our goal in writing this book has been to provide a context for the creation of the Eleanor Roosevelt National Historic Site and the Eleanor Roosevelt Center at Val-Kill. It is an attempt to document an important chapter in our local history which so often would be neglected without the quiet perseverance of the Dutchess County Historical Society. The "truths" of history are often elusive; we apologize for any errors that have unwittingly crept in, and we welcome corrections.

One

A Daughter of the Hudson Valley

The story of a tall, serious young woman with beautiful eyes and hair and a shy smile who became "First Lady of the World" begins in the Hudson Valley where Eleanor Roosevelt was born, grew up, and married. Here, she learned the lessons that enabled her to walk as easily with royalty as with local neighbors around the modest home she later made for herself at Val-Kill, near the Hyde Park hamlet in Dutchess County.

She was a child of the river families society: descendants of the earliest European adventurers and entrepreneurs who made the Hudson a pathway to the treasures of this continent and the world, carving out manorial estates and establishing themselves as the valley's owners. She inherited both this family history and a tradition of strong women of Dutch and English backgrounds who controlled their own lives, managed huge land holdings, handled personal fortunes and large families and adversity in times of great stress, yet who also served as models of social decorum and charity.

An understanding of Eleanor Roosevelt requires knowledge of her deep roots in the Hudson Valley. Its history is the taproot of her personal history.

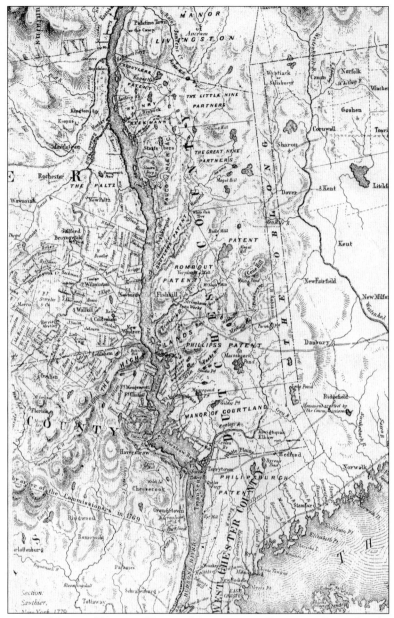

SECTION OF 1779 MAP OF HUDSON VALLEY MANORS AND PATENTS. River family ownership began in the 17th century with Dutch patroonships such as Rensselaer wyck in the Albany area. Following English takeover of Nieuw Amsterdam in 1664, patroonships were grandfathered through manor and crown patents then issued by British monarchs. Patroonships and manors conveyed both title and judicial oversight of a territory to the patroon, or lord. Patents, although powerful development tools for the Crown and moneymakers for the patentees, conveyed no rank or form of address. River families inherited land, money, and privilege. Robert Livingston, the landless younger son of a Scots minister, came here to make his fortune. In 1683, he married Dutch widow Alida Schuyler Van Rensselaer and became lord of Livingston Manor when granted 120,240 acres south of Rensselaer wyck. It was the start of a family empire, which continued to flourish, creating the quasi-feudal society into which Eleanor Roosevelt was born. (DCHS.)

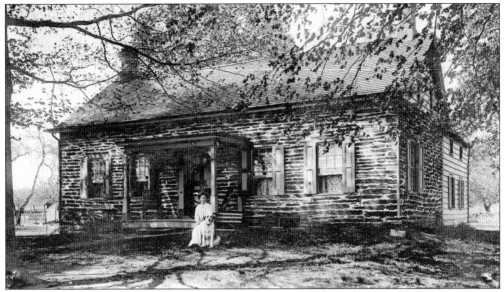

WILLIAM STOUTENBURGH HOUSE. Patent holders included river manor lords (Van Renssalaer, Philips, Livingstons, for example), government servants, New York City merchants, and daring speculators. They encouraged settlement through leases or sales. Access to river transportation was the key to success. Leaseholds kept land in the hands of original owners, despite lessee improvements. Modest stone houses like this could be the start of a fiefdom, a community, or only a rental. (J&MS.)

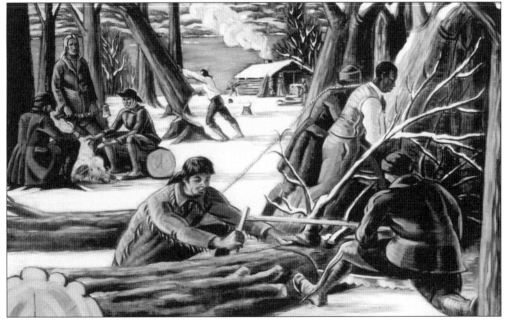

STOUTENBURGHS, DOWS POST OFFICE MURAL. The values placed on land and natural resources in the 18th century had long-term political and social effects of defining growth and establishing quasi-feudal castes: owners, servants, and farmer-merchant classes. Some owners, like Jacobus Stoutenburgh, whose family first settled present-day Hyde Park, encouraged neighbors and settlement through sales and development of trading companies. (JG.)

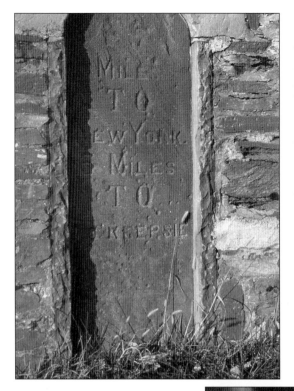

STONE MILE MARKER. The Queen's (later King's) Highway-Albany Post Road was established in 1703 for post riders between New York City and Albany. It marked the beginning of public roads replacing narrow Indian trails on both sides of the river and inland. Roads encouraged industrial development: fishing, lumbering, tanneries, and gristmills. Iron mines, shipbuilding, and the beginning of trade farther afield before the American Revolution increased river family wealth. (JG.)

MARGARET BEEKMAN. A route to profitable proprietorship was intermarriage. It linked Ulster's Beekman family holdings with Livingston lands. Margaret Beekman's union with cousin Judge Robert Livingston Jr. continued this pattern. Beekman patronage helped build a church for German Palatine immigrants sent here around 1715 by Queen Anne. The church walls witnessed many marriages by leaseholders and their descendants. (NYSOPR&HP.)

CHANCELLOR ROBERT R. LIVINGSTON. Everyone wanted the economic liberty to succeed or fail enjoyed by river families. An aborted Rent War of 1766, led by Pawling's William Prendergast before the American Revolution, highlighted differences between tenants and big landowners. It signaled the same problems that later separated the Colonies from England. Eleanor Roosevelt's direct ancestor Chancellor Robert R. Livingston threw his fortunes with revolutionaries when he helped draft the Declaration of Independence. (NYSOPR&HP.)

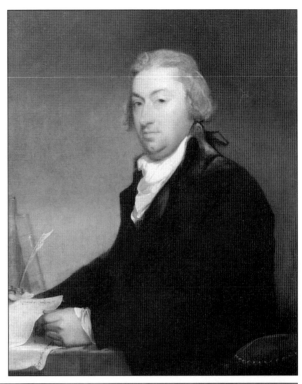

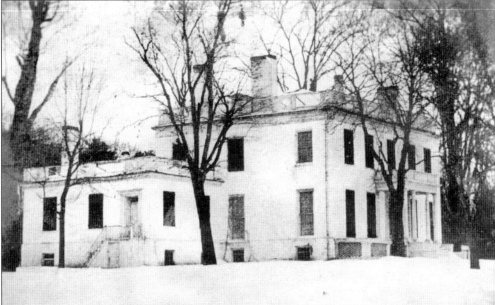

LIVINGSTON'S CLERMONT. Revolution increased all women's burdens. Following men or remaining behind meant loneliness, handling children, adding men's work to household duties, and meeting enforced quotas to satisfy soldiers' needs. Landlords' wives, also responsible for the welfare of servants and slaves, ran farms and industries needed to support troops. The chancellor's aged mother, Margaret, fled Clermont when Vaughan's raiders burned it in 1777 but returned immediately to rebuild. (NYSOPR&HP.)

GEN. RICHARD MONTGOMERY. Janet Livingston, a strong Hudson Valley woman, lost husband Gen. Richard Montgomery, Revolutionary War hero, in the Battle of Quebec. Dutch women held equal legal footing with men, but English women lost property rights when married. Widow Janet Livingston took control of her own life, renting her Rhinebeck mansion, Grasmere, to sister Gertrude, New York's First Lady. She planned Montgomery Place for herself, selling Grasmere to yet another sister. (NYSOPR&HP.)

BARDS, DOWS MURAL. Tory physicians John and Samuel Bard of Hyde Park's Red House were among the few to survive Revolutionary divisions. Their medical skills protected Washington and Franklin. Scientific achievements, integrity, and civic generosity kept them free from patriot ire. Bard gifts provided New York City's first hospital, land for St. James Church, and support for schools and colleges—all helping to build an Empire State. (JG.)

ST. JAMES, DOWS MURAL. Religious tolerance remained high despite the war. English churches, closed during the Revolution, reopened doors to congregations freed from Crown oversight. Union churches, built by organizations like the Stoutsburgh Religious Association, served many community congregations and faiths. Hyde Park Roosevelts' parish, St. James, formed as a congregation in 1811, was built on Bard land in 1846 with river families' support. (JG.)

MORGAN LEWIS HOUSE. Morgan Lewis was an early governor of New York. Staatsburgh was his mansion. Revolutionary service balanced war's costs with rewards of Tory lands. Service afforded participation in framing democracy's structure. Isaac Roosevelt, who formed his own militia, was repaid in land. Later, as a delegate to New York's 1788 Ratification Convention in Poughkeepsie, he supported joining the federation, which made Franklin Roosevelt very proud. (CSP.)

15

ROBERT FULTON. New York, the new nation's most ravaged state during the Revolution, achieved financial recovery quickly, supported by robust New York harbor and river traffic, which continued to feed the economy through the years. Robert Fulton's steamboat invention in 1807 attracted Livingston patronage and Harriet Livingston as his bride. New blood introduced a global facet to family life and gave his steamboat, the *Clermont*, a family name with docking privileges. (NYSOPR&HP.)

STOUTENBURGH CEMETERY. Family cemetery gates bear Dutch family crests, but headstones reveal society's changing composition, ranging from slaves to English, Germans, and Hispanics. Rapid changes everywhere pre–Civil War were felt at all levels of valley society. Continental territorial expansion, slavery's end in New York (1828), Far Eastern and West Indies sea trade, the gold rush, and European wars and immigration changed local and regional communities to reflections of the world. (J&MS.)

STAATSBURG COAL YARD. Franklin Roosevelt's father owned this coal yard and Pennsylvania mines. The 19th-century railroads altered local economies and industries. Postal hamlets became freight storage terminals for raw materials from afar, powering and supplying factories, homes, and expansion of river family and nouveaux riches estates. Nearby estate "Staatsburgh" was beautified by financier Ogden Livingston Mills with a family fortune earned by father Darius Mills, who supplied gold rush miners. (CSP.)

NORTHERN DUTCHESS FARM FAMILY. As manufacturing turned dockside areas of valley cities to industrial activity, rural areas and farmland became prized as open space for new uses. Those who owned small farms inland—often with roots as deep in the area as river family members—felt a strong pride in their own family's history, their land, and their work. They often resisted change and new ideas. (CSP.)

VIOLET GROWERS. Hamlets near estates, service centers for local farm and mill workers, also housed estate staff and attracted streams of visitors by rail to local stations and private railroad sidings. Such travel marked the beginning of regional middle-class tourism. Nearby farms saw opportunity in becoming summer boardinghouses. Others invested in visitors' tastes, seeing prosperity in greenhouse violet production for bouquets here and in New York City. (CSP.)

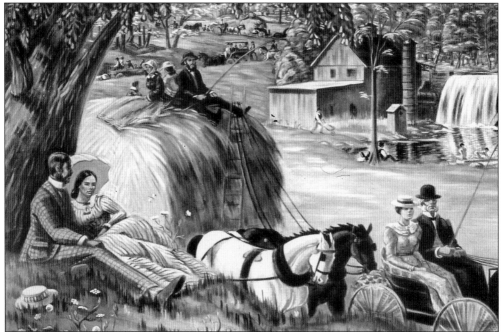

MARKET DAY TRIPS, DOWS MURAL. Weekly shopping trips carried local families past estate walls. The lives of these people, centered around work and family and touched estate dwellers only peripherally when politics, economics, cultural, or community institutions invited or forced interaction. When Eleanor Roosevelt was born, three separate societies existed in the valley: river families, those who relied upon estates for a living, and other local residents. They each lived in very different worlds. (JG.)

FDR History Booklet. Eleanor and Franklin Roosevelt were distant cousins linked by common 17th-century ancestor Claes van Roosevelt. Genealogical lore among river families was known from childhood. This booklet, produced with Franklin Roosevelt's encouragement, was intended for a broader audience to show his family as leaders, rooted in American history and values. Eleanor Roosevelt's links to greatness were as close as her uncle Pres. Theodore Roosevelt. (J&MS.)

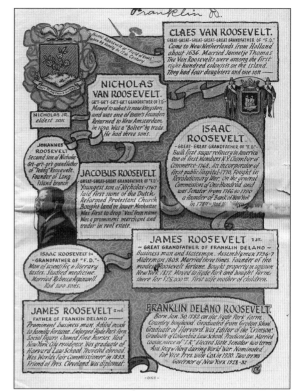

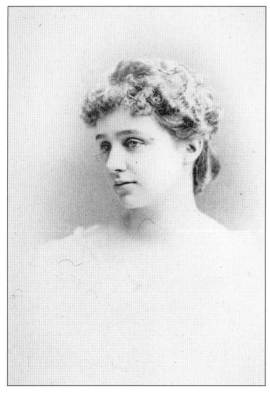

Anna Hall. Eleanor Roosevelt's Livingston roots came through her mother, a lovely, well-brought-up charmer from a traditional Victorian household. Lessons in social duty, good manners, religion, education, and appearance provided insufficient preparation for the real problems Anna Hall Roosevelt faced in her marriage. It had seemed a love match, but responsibilities, illness, and childbearing burdened her life, and diphtheria ended it when daughter Eleanor was only eight. (FDRL.)

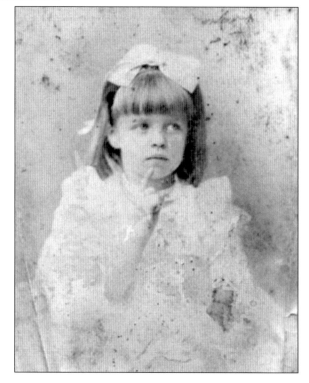

ELLIOTT ROOSEVELT'S LETTER. Eleanor's father, Elliott Roosevelt, was Theodore Roosevelt's younger brother. He was a romantic young man, burdened by poor health and addiction. Attempts to escape or master his problems, expressed through daring horsemanship and exotic world travel, exhausted his inheritance. Although his long absences distressed his family, he endeared himself to his daughter in letters full of creative tales, drawings, and Learlike poems that made him a hero in her eyes. (FDRL.)

ELEANOR ROOSEVELT AT FOUR. Eleanor's parents were part of New York's fashionable young married crowd, whose social calendars overflowed. Maintaining and staffing city homes, frequent entertaining, travel and child-rearing costs took their toll on finances and relationships. A serious little girl felt disappointment in the nickname "Granny," given to her by her beautiful, clever mother. Elliott Roosevelt saw his "Nell" differently. Even at four, her eyes reflected an endearing sensitivity. (JEL.)

GRANDMOTHER HALL. Mary Livingston Ludlow married country gentleman Valentine G. Hall, who dabbled in theology and concerned himself with his library, horticultural matters, and business affairs. When Hall died, his staunch Victorian views and handling of parental duties left his distraught, protected wife totally unprepared to manage a household of spirited, uncontrollable young adults. Grandmother Hall had depended for guidance upon daughter Anna, who was now gone. (FDRL.)

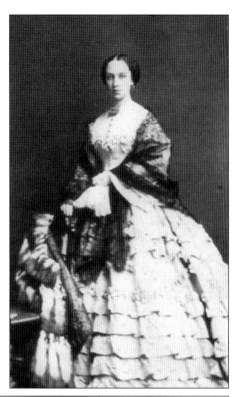

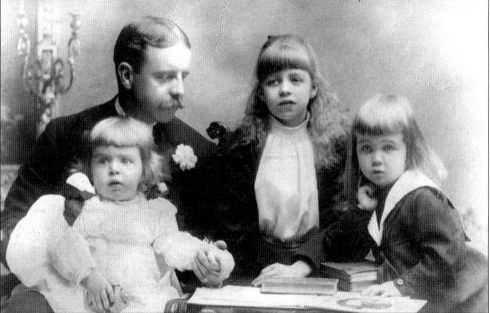

ELLIOTT ROOSEVELT AND CHILDREN. His wife's death chastened Elliott Roosevelt but hastened his own end. Marriage troubles had convinced his wife that he could not handle parental duties. At her wishes the children were separated from him; she named her mother as guardian. The loss to both children and father is visible in photographs like this one. Grandmother Hall took on the added responsibilities and discouraged the father's visits as intrusive. (FDRL.)

OAK LAWN. The children's lives changed radically when sent to live with widowed Grandmother Hall in this big brick country house overlooking the Hudson, north of Tivoli, the nearest village. A wide veranda encircled the house and looked westward over the river to distant Roundtop, in the Catskill mountains. There was not another house in sight. In this rural setting, where they had earlier spent summer vacations with parents, they now lived, at their mother's wishes, far from the father they adored, cared for by uninterested or grudging servants in the dysfunctional household of their mother's younger siblings. In her various memoirs, Eleanor Roosevelt recalled the loneliness of the newly orphaned Roosevelt children there in a house she would always associate with the absence of her father and the death of her baby brother, Elliott Roosevelt Jr. (JEL.)

SPRINGWOOD. Early manor and country seat homes were often spacious, sturdy farm houses. A glimpse of Franklin Roosevelt's happy childhood shows him in front of his parents' rambling frame Victorian farmhouse with favorite dogs. He redesigned the house in 1914, with mother Sara Roosevelt's oversight. It was nevertheless a farm, carefully managed by her to support the needs of family, staff, and the entertaining required of her social set. Young Eleanor and her father, who was Franklin Roosevelt's godfather, were among the welcome family visitors here. The wings, added by Franklin Roosevelt, addressed the family need for additional space in which to entertain. The exterior Georgian features were similar to changes made to many of the big houses during the Gilded Age, when affluence and exposure to cosmopolitan fashion and ideas of beauty encouraged competition among old and new wealth to outdo each other in beautifying homes. Interiors were refurnished with European antiques, as exteriors and grounds bore the imprint of architects like McKim, Mead and White. The Gilded Age brought estate culture to its apex. (FDRL.)

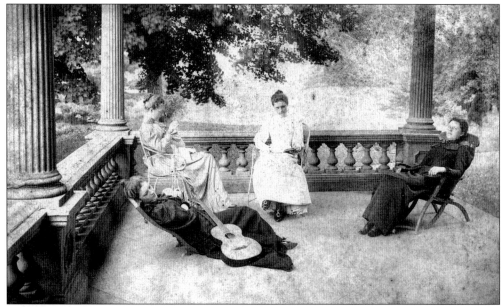

ROKEBY. Gen. John Armstrong built Rokeby for wife, Alida, a Livingston, around 1810. It has since been occupied by descendants. The children of J. W. Chanler and Margaret Astor Ward came here after their parents' deaths. These "Astor orphans," like Eleanor Roosevelt, grew to have strong characters and make their mark on history. They were blessed, however, with a caring, motherly cousin as guardian, assisted by staff devoted to the children. (RC.)

DELANO ESTATE. By the end of the 19th century, marriage outside the original Dutch-English river family lines had introduced many new faces and backgrounds. Wealth, acumen, and connections created strong links. Steen Valetje (Dutch for "small stony creek"), built next to Rokeby in 1851, was the home of Astor heiress Laura Delano and Franklin Hughes Delano, Sara Delano Roosevelt's uncle. Franklin Delano Roosevelt was named for this great uncle. (RC.)

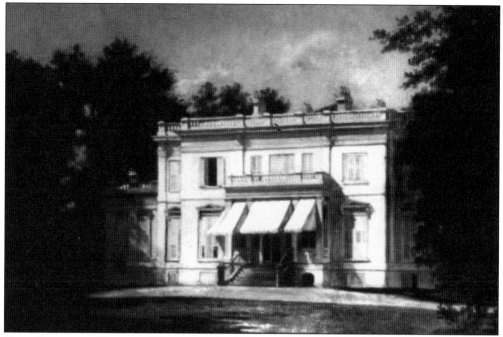

THE LANGDON ESTATE. The portrait of Eleanor Roosevelt's childhood environment is a landscape dotted with the great houses of river families and nouveaux riches, served by dependent staff living within more independent communities. Bard's Red House and arboreal experimental grounds, later the Langdon estate, painted by Carmeincke, became Vanderbilt's magnificent beaux arts seasonal retreat. Awareness of social differences here contributed to Eleanor Roosevelt's sensitive nature. (DCHS/NPS.)

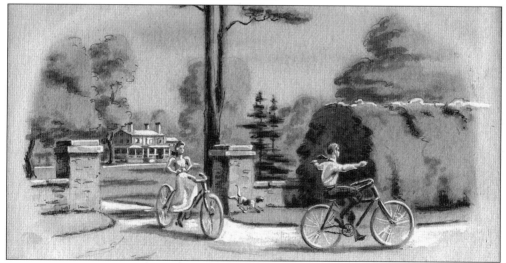

FRANKLIN ROOSEVELT AND MARY NEWBOLD. Lifelong friendships within their circle began as playmates, party guests, or classmates, home-tutored together, until both boys and girls were sent off to exclusive private schools. Neighbors often became family. Bellefield was the home of the Newbolds (later the Morgans), who were Roosevelt next-door neighbors. The joy of Mary Newbold and Franklin Roosevelt cycling together was captured by Olin Dows in this drawing. (GM Jr.)

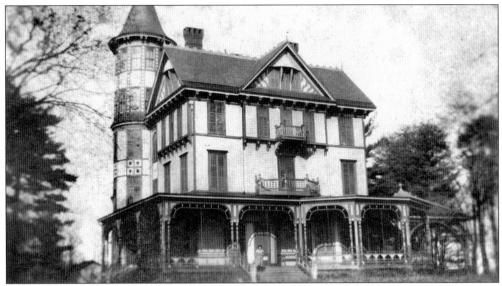

MARGARET SUCKLEY, WILDERSTEIN. Another Roosevelt distant cousin's home was Wilderstein. This ample Victorian house was, like the Roosevelt dwelling, a warm family center. Margaret "Daisy" Suckley, who died in 1999 and was the last of the family to inhabit it, gave Fala to Franklin Roosevelt. In recent years, the house and Suckley historical memorabilia have been saved to become the area's latest historical treasure. (WP.)

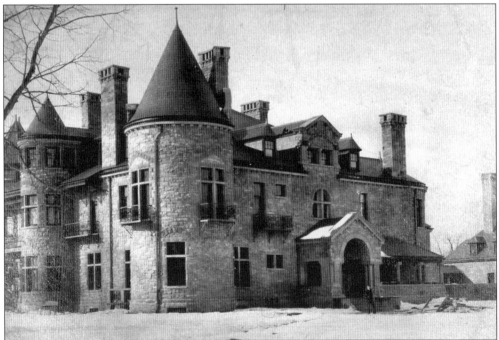

ROGERS FAMILY HOME, CRUMWOLD. A Roosevelt neighbor and friend was Col. Archibald Rogers, a talented engineer of modest circumstances who married wealth and increased family fortunes through railroading. Crumwold was designed by Richard Morris Hunt. Franklin Roosevelt was tutored in a tower playroom here with Edmund Rogers, his five siblings, and the sons of the rector of St. James. The Rogers family remained part of the Roosevelt circle. (FDRL.)

ELEANOR ROOSEVELT AND BICYCLE. Playmates at Oak Lawn were few: a DePeyster daughter, with whom Eleanor Roosevelt was tutored, and brother Hall Roosevelt. Companionship was a long bicycle ride or pony ride away. She had her own pony and, as Franklin Roosevelt later often said, "sat a horse well." Not until she was 15 and went away to school in England did she know the joy of being with young people her own age. (FDRL.)

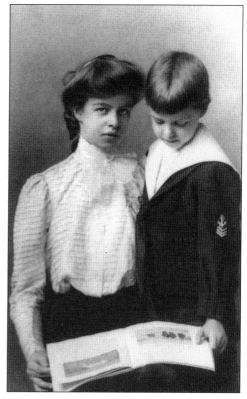

ELEANOR AND HALL ROOSEVELT. Even before she left for Allenswood, Mademoiselle Souvestre's school in England, she was beginning to blossom. Her concern and love for brother Hall never diminished, but the intelligence, courage, and sensitivity that were nurtured by the school's director, her mentor and friend, marked the beginning of a new, more educated, experienced, and self-assured young woman. (FDRL.)

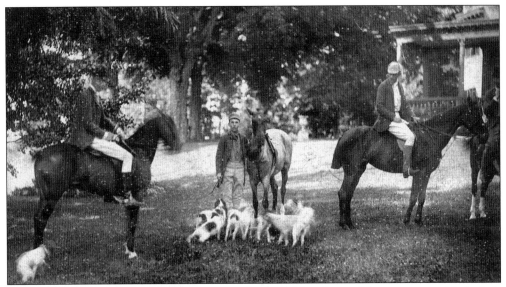

ROKEBY HUNT. As their children approached adulthood, wealthy parents guided their encounters in formal and informal settings. Young people among the river families had to be prepared for the adult lives that they would inherit. Horsemanship was a valued social skill for both young men and women. Hunts, hunt balls, and related social events at estates up and down the river were appropriate meeting places. (RC.)

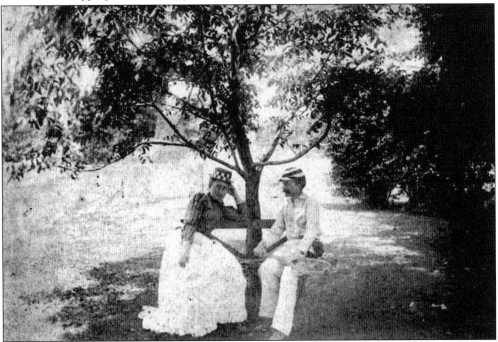

EDGEWOOD CLUB TENNIS DUO. The Halls were founding members of Tivoli's Edgewood Club in 1884; the first country club in the area quickly became an acceptable meeting place for young people, who gathered in chaperoned social settings. Grandmother Hall was membership chair. The exclusive membership included all the right families. Teas, luncheons, and sports events allowed appropriate friendships to flower. Afternoon tea is still enjoyed there by members. (JEL, NA.)

AN ENGAGED DEBUTANTE. Eleanor Roosevelt's "coming out" in New York City opened the door to a fuller social and civic life through the work of the newly formed Junior League. The discovery of excitingly similar intellectual and social views brought Eleanor and Franklin Roosevelt together. Chaperoned parties, such as this one photographed by Franklin Roosevelt, were a setting for their romance and betrothal. (FDRL.)

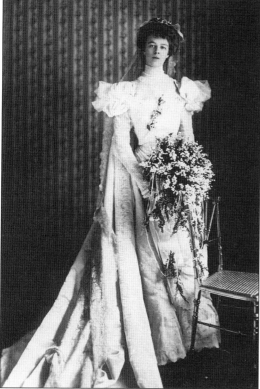

ELEANOR ROOSEVELT, BRIDE. Her beauty transcended the commonplace, as this photograph proves positively. Eleanor Roosevelt was not an "ugly duckling." She combined beauty and enormous strength of character, tested by her New York City wedding on St. Patrick's Day in 1905. Her Uncle Theodore, the nation's president, who gave her away, stole the limelight from the newlyweds. As Mrs. Franklin D. Roosevelt, she was to face many more difficult tests. (FDRL.)

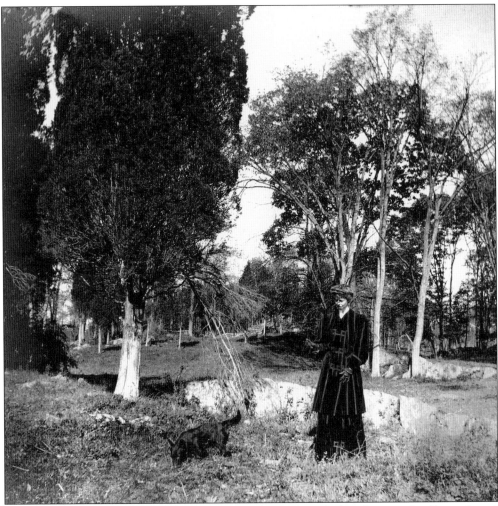

AT BARD ROCK, HYDE PARK, 1905. Franklin Roosevelt took this photograph of his wife and their first Scotty, Duffy, down by the Hudson River. While Franklin studied law at Columbia in New York City, the couple lived in a hotel but came often to Springwood, in Hyde Park. After he finished law school, the Roosevelts moved into a double house with his mother, which she had purchased and furnished. Eleanor Roosevelt continued to belong to the Junior League, but her mother-in-law soon insisted she stop going to the settlement house lest she carry germs back to her growing family. Later, Eleanor Roosevelt wrote that during the early years of her marriage she used to knit, embroider, read a lot, and keep up her languages—French, Italian, and German. Anna, James, Franklin Jr. (who died at seven months), and Elliott were born between 1906 and 1911. The second baby to be named Franklin Jr. arrived in 1914, and John's birth in 1916 completed the family, who all loved the Hudson Valley. (FDRL.)

Two

ELEANOR ROOSEVELT
1905–1945

The roles of wife, daughter-in-law, and mother defined Eleanor Roosevelt's life during the early years of her marriage. In 1910, she played an insignificant part in her husband's successful campaign for state senate. However, the move to Albany made her begin to feel less dependent on her mother-in-law, as did the 1913 move to Washington, D.C. With America's entry into World War I, she began to exercise her dormant executive talents through her work with the Red Cross. Her visit to the battlefields in France after the war helped to make her a lifelong advocate for peace.

The 1920s broadened her outlook immeasurably and began an educational process that contributed to her deepening understanding of people of all backgrounds. She joined the League of Women Voters, the Women's Trade Union League, and the Women's Division of the Democratic State Committee. The Stone Cottage and furniture factory at Val-Kill were built. She also began to teach at the Todhunter School in New York City.

After her husband's election as governor, she continued teaching and also began to earn money through her writing, speaking, and broadcasting work—activities she continued throughout her life.

As First Lady, she traveled throughout the country and the world and brought her knowledge to the Hudson Valley, where various New Deal projects were tried. Equally comfortable entertaining royalty as addressing a group interested in workers' education, she maintained her passion for learning and her commitment to working to find solutions to people's problems.

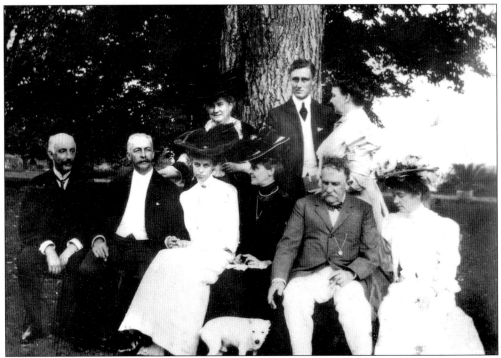

ELEANOR, FRANKLIN, AND SARA DELANO ROOSEVELT AT ALGONAC, NEWBURGH. This photograph shows a rather somber and shy Eleanor Roosevelt as a young bride seated amidst the family of her mother-in-law at Algonac, the Delano home on the Hudson. Her oldest grandchildren remember her taking them to see the site years later and telling them about that side of the family. (FDRL.)

ROBERT CHANLER. At another river estate, Rokeby, political ambition flourished. This "Astor orphan" had studied art in Paris, decorated mansions in New York City, and served in the New York State Assembly. In 1906, Robert Chanler ran for sheriff of Dutchess County. Often wearing a western sheriff's outfit, he gave elaborate picnics, sponsored marching bands and baseball teams, and lent his prize bull to his neighbors—a winning strategy. (RC.)

LEWIS, WILLIAM, AND ROBERT CHANLER. William Chanler had represented a New York City district in Congress, but his brothers' success in winning office as Democrats in a heavily Republican area was rare indeed. Lewis Chanler was elected lieutenant governor and later state assemblyman. Franklin Roosevelt had thought at first of running for this seat, but Chanler refused to give it up; hence, Franklin's decision to run for the state senate. (RC.)

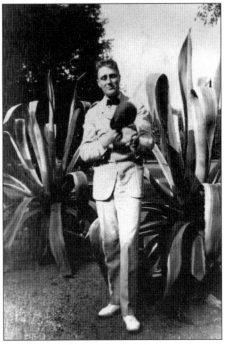

ROOSEVELT, 1910. Franklin Roosevelt threw his hat into the political arena, planning to build on the Chanler successes. Following their example, he campaigned by automobile. In his state senate race, he carried even Dutchess County (unlike his four presidential campaigns). In later years Eleanor Roosevelt recalled wanting her husband to win just because he was running and he might do something of value for the area. (RC.)

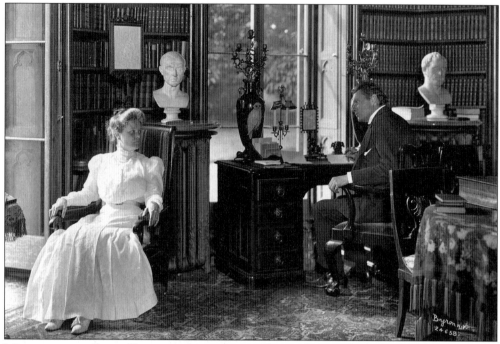

MARGARET AND LEWIS CHANLER. In contrast to Eleanor Roosevelt's lack of interest in politics at that time, Margaret Chanler had taken an active part in her brother's political adventures. She had organized clambakes and had made Rokeby campaign headquarters. Several years later, she presided over a reception in Poughkeepsie for Carrie Chapman Catt, who was promoting women's suffrage, an idea endorsed by Eleanor Roosevelt after her husband supported it. (RC.)

A GATHERING AT BLITHEWOOD, ANNANDALE. Eleanor Roosevelt is again in the shadows at this 1911 function with Governor Dix at the home (now Bard College) of Captain Andrew Zabriskie, a county Democrat and collector of Lincoln tokens, medals, political badges, and other coins and medals. Franklin Roosevelt's election as state senator resulted in the family's move to Albany and his wife's getting to know people of differing backgrounds. She began to feel more independent. (FDRL.)

With Daughter Anna and Her Horse Daisy in Hyde Park. Nevertheless, Eleanor Roosevelt's primary roles continued to be those of wife and mother. In 1913, the family moved to Washington, D.C., when Franklin Roosevelt became assistant secretary of the Navy. With the entry of the United States into World War I, Eleanor Roosevelt began to show her executive talents, organizing Red Cross canteens. (FDRL)

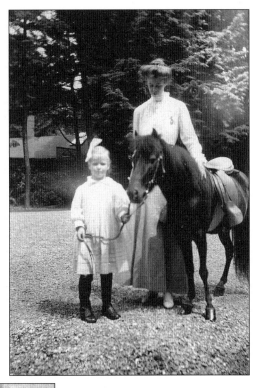

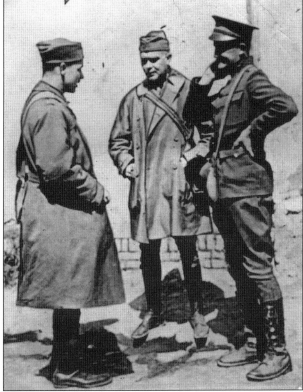

Gerald Morgan Sr. in France, World War I. Gerald Morgan, a neighbor who had married Franklin Roosevelt's childhood friend, Mary Newbold, served as a press officer to General Pershing during the war. After the war ended, the Roosevelts traveled to France, where their visit to the battlefields on which so many millions had died contributed to Eleanor Roosevelt's lifelong commitment to find peaceful solutions to world problems. (GM Jr.)

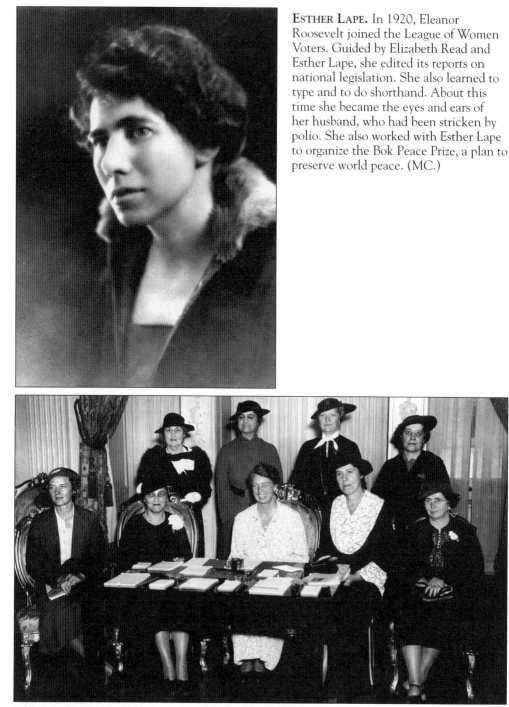

ESTHER LAPE. In 1920, Eleanor Roosevelt joined the League of Women Voters. Guided by Elizabeth Read and Esther Lape, she edited its reports on national legislation. She also learned to type and to do shorthand. About this time she became the eyes and ears of her husband, who had been stricken by polio. She also worked with Esther Lape to organize the Bok Peace Prize, a plan to preserve world peace. (MC.)

WOMEN'S TRADE UNION LEAGUE, NEW YORK CITY. Having joined the Women's Trade Union League in 1922, Eleanor Roosevelt continued to support its efforts to improve women's working conditions. She also contributed substantial financial assistance to pay off the mortgage of its clubhouse, where she was a frequent visitor. At the extreme left is Rose Schneiderman, who helped to educate the Roosevelts on labor issues. (NYURFWLA.)

WITH MARY SIMKHOVITCH, NEW YORK CITY. Another person who influenced Eleanor Roosevelt was Mary Simkhovitch, founder and executive director of Greenwich House, a settlement house. She observed: "But to help means, first of all, to understand, and there can be no understanding without participation." Eleanor Roosevelt learned the importance of personal participation and the need to have a sense of personal responsibility to the community. (NYUTIL.)

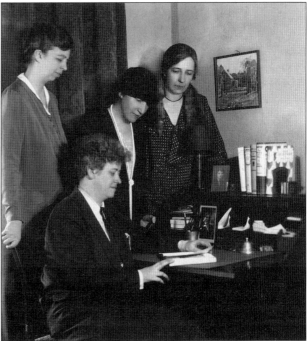

WITH FRIENDS. About 1922, Eleanor Roosevelt met, from left to right, Nancy Cook, Marion Dickerman, and Caroline O'Day. Active in the Women's Division of the Democratic State Committee, in 1924, they traveled around the state, organizing women's units in every county. As a result of this campaign, the *Women's Democratic News* was created to strengthen the relationship between upstate and downstate voters. Eleanor Roosevelt was its editor and treasurer until her husband was elected governor. (FDRL.)

VAL-KILL. Picnics were a favorite pastime for Eleanor Roosevelt, Nancy Cook, and Marion Dickerman. In the fall of 1924, Franklin Roosevelt suggested that they build "a shack" along the stream on this Roosevelt land. With Henry Toombs as architect, Franklin Roosevelt became the general contractor for the construction of Stone Cottage, built in the Dutch vernacular tradition. Val-Kill Industries, to train rural youth to construct furniture based on early American designs, soon followed. (NPS.)

WITH HER CAR. In 1917, Eleanor Roosevelt had been invited to form a motor corps for the Red Cross but had refused because she did not drive. However, a few years later, she had learned, and under the tutelage of her husband's preeminent political adviser, Louis Howe, she undertook the basic job of driving voters to the polls. Camping trips were another favorite use of the car. (NPS.)

CARRIE CHAPMAN CATT. In 1927, Eleanor Roosevelt invited Carrie Chapman Catt (right) to Hyde Park to discuss the proposed Kellogg-Briand Pact, an effort to outlaw war. In 1914, Catt had conducted a suffrage school in the courthouse in Poughkeepsie before the reception presided over by Margaret Chanler Aldrich. She gave the keynote speech at this meeting to support the women's peace movement. (FDRL.)

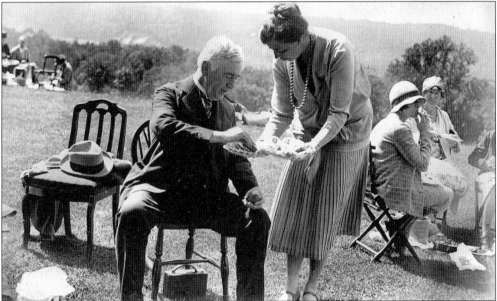

DUTCHESS COUNTY HISTORICAL SOCIETY PILGRIMAGE, 1927. Eleanor Roosevelt continued the role of supportive wife, shown here serving tea to John J. Mylod, a leader of the Dutchess County Historical Society. Her husband was a charter member of the organization and collaborated closely with Helen Wilkinson Reynolds, noted local historian. Later, Eleanor Roosevelt, too, became active in preservation efforts, working to thwart the grandiose plans of Robert Moses for Washington Square in New York City. (FDRL, DCHS, WW.)

Inauguration
(of)
Franklin D. Roosevelt
January First
1929

ROOSEVELT INAUGURATED GOVERNOR, 1929. Guided by Louis Howe and no longer so self-effacing, Eleanor Roosevelt helped convince her husband to run for governor and played an important role in his election. She became an effective campaigner and headed the women's activities for presidential candidate Al Smith. At this time she also began to earn her own money by writing, teaching, lecturing, and broadcasting. (PC.)

THE ANDROS TWINS. Margaret and Elisabeth Andros were active in the Franklin D. Roosevelt Home Club, formed at Roosevelt's request to keep local people up to date on current events. They were among a contingent of over 150 people from Hyde Park arriving in Albany to visit the governor and his wife, who, according to a newspaper article, had a personal word of greeting for everyone there. (PC.)

AT THE TODHUNTER SCHOOL, NEW YORK CITY. During her husband's gubernatorial terms, Eleanor Roosevelt continued to teach at the Todhunter School, which she co-owned with Marion Dickerman and Nancy Cook. Practicing what she had learned during her own schooldays, her work at the settlement house, and the tours taken on behalf of her husband, she expanded the horizons of her students by taking them all around New York City. (FDRL.)

HAZEL LEWIS LEPORE AND SISTER IN DUTCHESS JUNCTION. In the early 1930s, Eleanor Roosevelt taught adults and children in Dutchess Junction how to sew. Adults worked on the material she brought for sheets and towels, while children practiced on pillowcases and washcloths. The finished products went home. Today, Hazel Lepore volunteers at the Fishkill Health Related Facility and attributes her sewing skill to those lessons of long ago. (HL.)

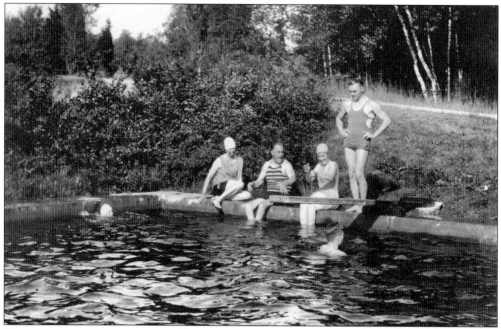

SWIMMING AT VAL-KILL. Family and friends all enjoyed picnicking and swimming at Val-Kill. Franklin and Eleanor Roosevelt are with Earl Miller, the state trooper who provided security for New York's First Lady during the gubernatorial years. Miller, who became devoted to her, accompanied her on investigatory trips taken on behalf of Franklin Roosevelt. The two remained friends until her death. (NPS.)

FLAG DAY, PHILIPSE MANOR HALL, YONKERS, 1931. Proud of their own patriotic ancestors who signed the Declaration of Independence and fought in the American Revolution, the Roosevelts celebrated Flag Day here, at the home of a Loyalist, Frederick Philipse III, lord of the vast Philipsburg Manor. Philipse's support of George III was so strong that George Washington ordered him arrested. Both Roosevelts knew and enjoyed American history. (NYSOPR&HP.)

FRANK LANDOLFA. Frank Landolfa, shown here with an example of his superb craftsmanship, and Otto Berge were the principal craftsmen of Val-Kill Industries. Landolfa's daughter recalls that he loved his work and took great pride in it and that Eleanor Roosevelt taught him how to drive. When Val-Kill Industries ended in 1936, Landolfa remained in Dutchess County with his wife, Rose, and their children. (AS.)

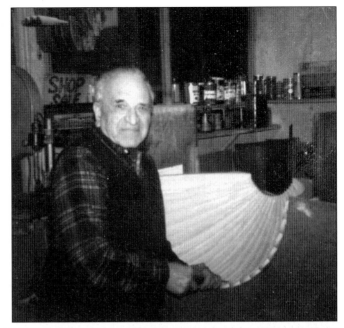

VAL-KILL FURNITURE. Eleanor Roosevelt, an enthusiastic marketing representative in her New York City apartment, is seen here with Dorothy and Edward Thomas Niles, who had earlier purchased a candle stand from Val-Kill Industries (signed by Frank Landolfa) and a small chair. When the story and photograph appeared nationwide, Dorothy Niles became famous in her former hometown, Galveston, Texas, thanks to the central telephone operator who spread the word. (PND.)

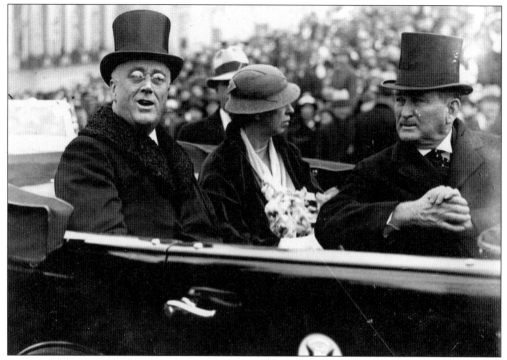

INAUGURATED AS PRESIDENT, 1933. Eleanor Roosevelt was not visibly elated at the historical occasion of her husband's 1933 inauguration as president. In fact, she worried that her duties would be ceremonial and that she would no longer be of "real use." Her fears were unfounded, and she became the most active First Lady in history, using her access to the president to push for help for those who would have been voiceless without her intervention. (FDRL.)

THE WHITE HOUSE
WASHINGTON

November 5, 1934.

Dear Mrs. Winter:

Betty and her husband were perfectly wonderful, and we were all thankful indeed that Vallie died peacefully at home. Many thanks for your kind note. I hope you are in better health and are having a fairly comfortable time.

Affectionately,

Eleanor Roosevelt

A LETTER. Even as First Lady, there were always reminders of family problems and her lonely childhood. As a young man, her Uncle Vallie had been a champion tennis player but had also amused himself by shooting at people coming down the long driveway to the family home, Oak Lawn, frightening the young Eleanor Roosevelt. Her own childhood unhappiness contributed to her sensitivity to others. (JEL.)

THE MORGAN FAMILY AT BELLEFIELD. The New Deal programs were never abstract concepts to Eleanor Roosevelt. In 1935, she asked Gerald Morgan, owner of the neighboring estate, to assist her in her project to "help people [of Hyde Park] get on a self-supporting basis. . . ." Several town meetings were held, but very soon, Pres. Roosevelt made it abundantly clear that neither he nor his wife had "individual plans for the uplift of the town." (GM Jr, J&GG.)

CIVILIAN CONSERVATION CORPS PROJECT IN STAATSBURG. The Civilian Conservation Corps built roads, constructed bridges, and erected a restaurant in Norrie State Park, which had been donated to the state by a sister of Margaret Lewis Morgan Norrie. Eleanor Roosevelt, Margaret Norrie, sisters Ruth and Geraldine Morgan Thompson, and brother Gerald Thompson were lifetime friends. New Deal ideas were often implemented in the Hudson Valley, often with the Roosevelts' personal attention. (FDRL.)

SHIRLEY VAUGHN JACKSON. Shirley Vaughn Jackson recalls sitting on her lawn in the late 1930s and seeing a slim black girl turn into her driveway to say that Mrs. Roosevelt had sent her to introduce herself to the one black family on Violet Avenue. The girl had just come to Val-Kill to work for Mrs. Roosevelt, who thought she might be lonely. Thus began a long and warm relationship between the Roosevelt and Jackson families. (SVJ.)

WELCOMING THE ROYAL VISITORS, 1939. Armed with an American flag and the Union Jack, Tom Morgan sat on the stone wall waiting for the royal couple to pass. His older brother, Gerald Morgan, Jr. had not been allowed to come home from Groton to see the English king and queen. The visit was an effort to influence American public opinion in favor of the Allies. (GM Jr.)

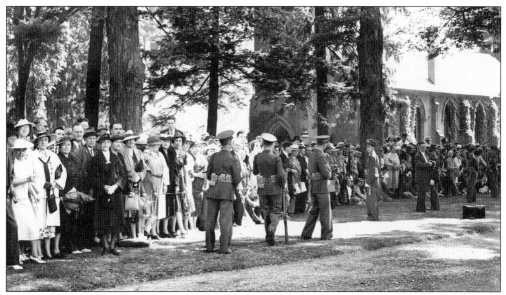

WAITING FOR A GLIMPSE. Hyde Park residents lined up to see the royal couple when they went to St. James's Church for the Sunday morning service. It was a time filled with anxiety, as Hitler continued to increase his power. Eleanor Roosevelt was aware that, despite her hatred of war, it might become the only way to preserve democracy. The people of Hyde Park, whether reluctantly for war or adamantly opposed, were captivated by the young royal couple. (PJ.)

PICNIC AT TOP COTTAGE. The informality of the event for the royal couple at Top Cottage (Franklin Roosevelt's recently built retreat near Val-Kill) is vividly shown in this charming photograph of a guest holding the little girl. It was a family occasion rather than a formal meal. Eleanor Roosevelt had chosen a menu that included not only the famous hot dogs but also Virginia ham and other typically American dishes. (RC.)

WITH WINSTON CHURCHILL. Although she had a very cordial relationship with the royal family and respected Winston Churchill's role during the war, Eleanor Roosevelt had reservations about Churchill's politics. Churchill, a conservative by nature and environment, held views that were more akin to those of landed American gentry than to the First Lady's evolving commitment to civil and human rights. (NPS.)

CATHARINE STREET COMMUNITY CENTER, POUGHKEEPSIE. Eleanor Roosevelt's commitment to civil rights was strong and lasting and personal. On the national level she worked tirelessly for the enactment of anti-lynching legislation and collaborated on many projects with Mary McLeod Bethune, noted African American educator. Here, she is as First Lady, visiting a thriving local community center. (DCHS/CSCC.)

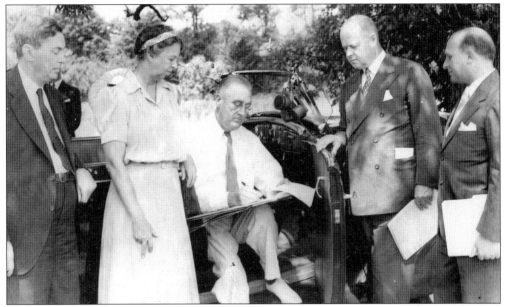

FRANKLIN D. ROOSEVELT LIBRARY, 1939. Just as Franklin Roosevelt had prided himself on his architectural and construction skills while Stone Cottage was being built at Val-Kill, he remained keenly interested in the progress of the first presidential library also built in the tradition of the Dutch vernacular style. Upon finishing his terms as president, he planned to spend quiet days in Hyde Park at the library. (PJ.)

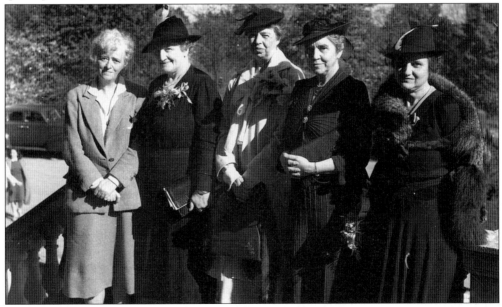

DUTCHESS COUNTY FEDERATIONS OF DEMOCRATIC WOMEN'S CLUBS CONFERENCE, VASSAR ALUMNAE HOUSE. Eleanor Roosevelt's attendance emphasized again the importance of women's participation in the political process. On the left is Nancy Cook, who remained active in Democratic affairs after the Val-Kill factory closed. On the right is Elinor Morgenthau of Fishkill, the Roosevelts' political and personal friend and the wife of the secretary of the treasury. (FDRL.)

49

FRANKLIN D. ROOSEVELT HIGH SCHOOL DEDICATION, HYDE PARK. Seen here are the president's mother, Sara Delano Roosevelt, aged 86, and his wife, Eleanor Roosevelt. Constructed in the native fieldstone preferred by the president, the new high school (now Haviland Junior High School) reflected Roosevelt's continuing interest in his hometown. Even when facing war, he always had time to concern himself with St. James's vestry, the library, and the schools. (FDRL.)

SARA DELANO ROOSEVELT AND FREDERIC DELANO, JUNE 1941. This lovely portrait shows the president's mother, just a few months before her death, and his uncle. Totally devoted to her son and to her grandchildren, Sara Roosevelt would perhaps have been happier if her daughter-in-law had followed the implacable rules of conduct expected of a woman of her heritage. And Eleanor Roosevelt would have found life easier without such a demanding mother-in-law. But they both endured with dignity. (RC.)

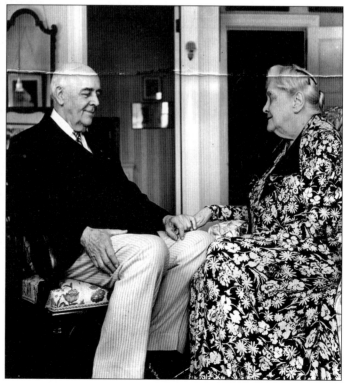

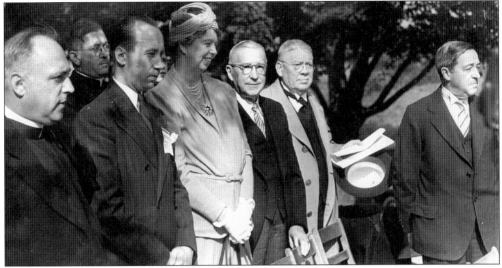

UNVEILING THE MONUMENT TO GENERAL PULASKI, POUGHKEEPSIE. The American Revolution had a special place in her heart in part because of the participation of her own ancestors. Eleanor Roosevelt was also aware that the Revolution's success was due to some degree to the important role played by men such as Gen. Casimir Pulaski from Poland. Even at its beginning, the nation drew upon diversity to fuel its evolution and strength. (PJ.)

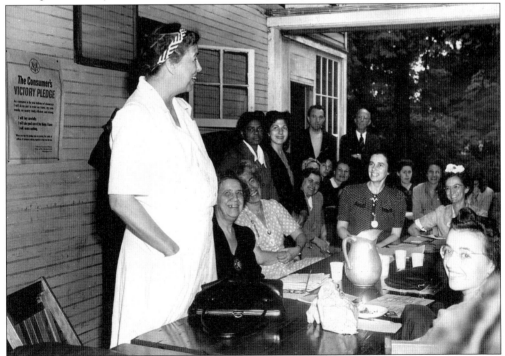

HUDSON SHORE LABOR SCHOOL, WEST PARK. Eleanor Roosevelt is seen once again in her role of teacher. The Hudson Shore Labor School was an outgrowth of the Bryn Mawr Summer School for Women Workers, a pioneer school in workers' education. In 1939, it moved to the West Park property of Hilda "Jane" Smith, a leader in worker education who was appointed a specialist in that field for the Federal Emergency Relief Administration. (FDRL.)

RALPH VINCHIARELLO, CHATHAM. Before going to Alexandria, Egypt (site of this photograph), Ralph Vinchiarello (left) arrived at the Brooklyn Navy Yard just in time to see Eleanor Roosevelt participate in the christening of the aircraft carrier *Yorktown*. He remembers that she had a terrible time breaking the bottle of champagne, but with a little help, she succeeded. Vinchiarello later was on escort duty when Franklin Roosevelt went to Yalta. (RV.)

SARKIS AND ARMINE ISBIRIAN. During the war, Eleanor Roosevelt—wearing a simple cotton dress, sandals without stockings, and a bandana in her hair—brought a small rug for repair to the oriental rug department in Luckey Platt's. An elderly Armenian worker asked who she was. "She is the queen of our land," replied Sarkis Isbirian, who had survived the genocide of the Armenians. Thinking of European royalty, the worker exclaimed: "What? That gypsy!" (AI.)

WITH AN INFORMAL GATHERING OF VASSAR STUDENTS, 1943.
Whenever Eleanor Roosevelt traveled, she communicated what she had learned through her newspaper column, her lectures, and meetings on college campuses. Here, she is shown talking about her visit to the troops in the Southwest Pacific, an experience that deepened her hatred of war. (VC.)

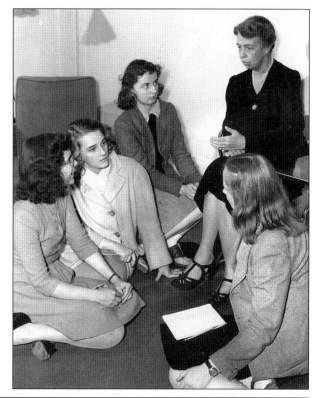

FUNERAL TRAIN, 1945. Franklin Roosevelt returned to his beloved Hyde Park to be buried at Springwood, his childhood home. He expressed his hope that his "dear wife" would also choose to be buried there. She did. And for the 17 remaining years of her life, she continued to call the Hudson Valley "home." The story was not "over," as she had modestly told the press. (FDRL.)

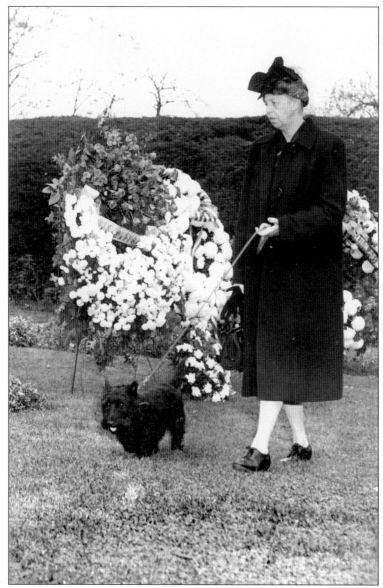

WITH FALA AT THE GRAVE. Eleanor Roosevelt is shown here looking at wreaths placed by United Nations delegates who had made a pilgrimage to Hyde Park. In December 1945, Pres. Harry Truman appointed her to the first American delegation to the General Assembly of the United Nations. In 1946, she chaired the commission that was the precursor of the United Nations Commission on Human Rights, which she also later chaired. While she traveled extensively, she was always happy to come home. In response to the Roosevelt children's request after Franklin Roosevelt's death, Margaret Suckley, who had given Fala to Franklin, gallantly relinquished him to Eleanor Roosevelt. Here Fala is attached firmly to his leash, but often he roamed freely in the woods of Val-Kill while his mistress called him by humming hymns she had learned as a child. In 1951, the readers of Eleanor Roosevelt's "My Day" column learned about the anxiety caused by his disappearance for 24 hours. After Fala's death, his descendants continued to live with her, exhibiting the Scotty characteristics of loyalty and mischief, combined with a strong dose of obstinacy. (PJ.)

Three

ELEANOR ROOSEVELT 1945–1962

After Franklin Roosevelt's death in April 1945, following his instructions and with the agreement of her children, Eleanor Roosevelt gave the Roosevelt home Springwood to the U.S. government. She also bought approximately 1,100 acres of his estate, including her cottage and the refurbished Val-Kill furniture factory. This is what she called home for the rest of life.

She enjoyed her many visitors who came to Val-Kill. Maureen Corr, her secretary from 1950 to 1962, recently explained: "She was relaxed; she was entertaining, rather than being entertained." Whether buttering rolls for Wiltwyck boys or receiving foreign dignitaries, she was always thoughtful about the needs of her guests. . . . She exhibited the same sense of fairness and friendly honesty when she was drafting the Universal Declaration of Human Rights with diplomats from around the world as she did when she was with people of the Hudson Valley.

During the last 17 years of life, she continued to work for what she believed in: human rights, education, peace, world understanding, dignity, equality, the importance of the arts, and the democratic process—to name only a few. She, herself, compared her curiosity to that of the monkey in the *Just So Stories*. She wrote and spoke about many issues, but more important, she learned about them firsthand by attending Parent Teacher Association meetings, visiting local synagogues and churches, talking with strangers on trains, encouraging young people, responding to people's queries, promoting participation in the political process, and, most of all, by listening.

Directly and indirectly Eleanor Roosevelt touched the lives of many Hudson Valley residents, who to her were individual human beings to whom she always wanted "to be of use."

GEORGE McCORNAC. Shortly after the president's death, George McCornac, retired Hyde Park banker, then a freshman at Franklin D. Roosevelt High School saw Eleanor Roosevelt and Fala—unescorted and with no fanfare—appear in the school hallways. She had written the foreword to the 1945 class yearbook, so he took his copy and asked her to sign it. Of course, she did. (GMC.)

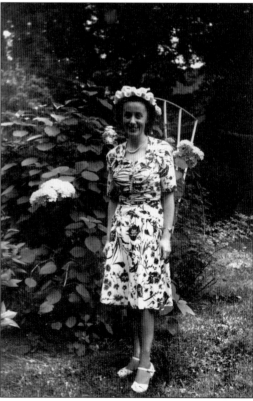

BETTY CASHIN REED, 1945. During World War II, Betty Cashin Reed boarded a crowded train in Beacon. A seated passenger saw her standing in the aisle, pulled a briefcase and papers aside, and said, "You can sit here, dear." The seated passenger was Eleanor Roosevelt, so recently First Lady, who kindly asked the woman about her plans for the day in New York City, and the two talked until they got off at Grand Central Terminal. (BR.)

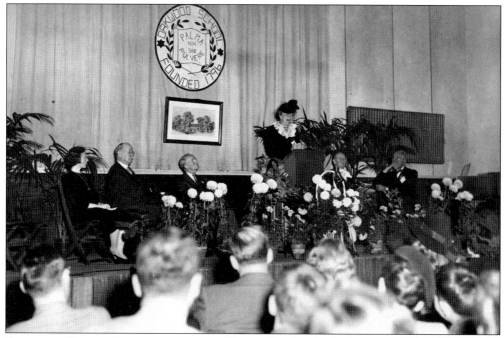

OAKWOOD SCHOOL SESQUICENTENNIAL. Eleanor Roosevelt, the keynote speaker, admired the Quakers for "their courage which comes from inner peace." She talked of the need to acquire serenity and goodwill and to create a sense of harmony with other nations, however difficult it might be. For her, the focus was on people and understanding how they live, their problems, and the reasons for their behavior. She was also the 1954 commencement speaker. (OFS.)

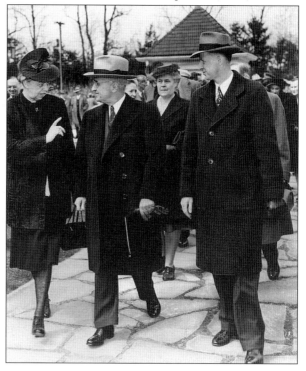

WITH HARRY TRUMAN, HYDE PARK. In spirited dialogue, Eleanor Roosevelt walked with Pres. Harry Truman at the dedication of the Roosevelt Home as a National Historic Site in April 1946. For herself, she purchased the refurbished Furniture Factory, her home at Val-Kill, and considerable acreage from her husband's estate to establish Val-Kill Farms with her son Elliott Roosevelt. She hoped it would be a profitable enterprise. It was not. (FDRL.)

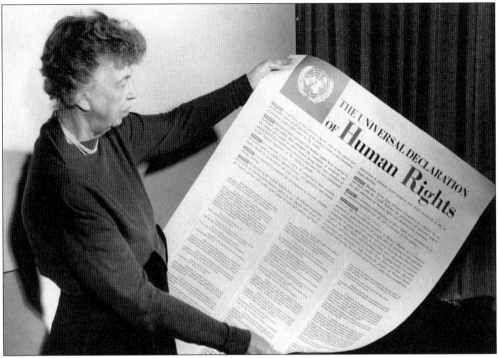

UN DECLARATION OF HUMAN RIGHTS. Honesty, intellectual ability, patience, personal friendliness, political acumen—all of these contributed to Eleanor Roosevelt's success in creating what became the world's yardstick for measuring the achievement of human rights. Adopted without dissent on December 10, 1948, the nonbinding declaration was to be accompanied by two covenants, one on civil and political rights and another on economic, social, and cultural rights. (FDRL.)

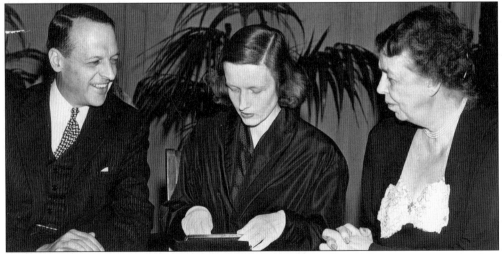

FOREIGN POLICY, POUGHKEEPSIE. In 1949, Eleanor Roosevelt spoke to a capacity crowd at Arlington High School on the issues between communism and democracy. For her, foreign affairs were not just about a declaration or about covenants. She believed in the importance of explaining ideas so that ordinary people could participate in discussing them and then use the political process to forward their goals. (PJ.)

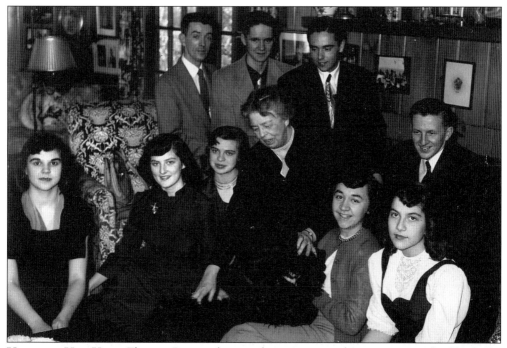

VISIT TO VAL-KILL. Eleanor Roosevelt was always interested in young people. Here, she welcomed for lunch Wappinger High School students, their teacher Dennis Hannan, and their foreign guest students. Bob Piggott recalls that just as they began to wonder how to handle the fried chicken, she picked up a leg with her fingers and took a bite. Any stray peas and rice were wolfed up by the canine vacuum cleaner, Fala. (RP.)

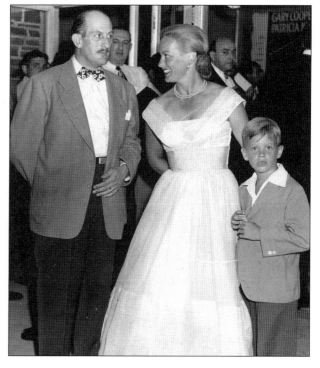

OPENING OF THE ROOSEVELT THEATRE. Phil Eisenberg (left) was a partner of Sidney Cohen and of Elliott Roosevelt in this enterprise, established across from the Roosevelt Home. A Howard Johnson's was also built there. With her son Scoop, Faye Emerson, married to Elliott Roosevelt at the time, was a welcome celebrity guest. (PC.)

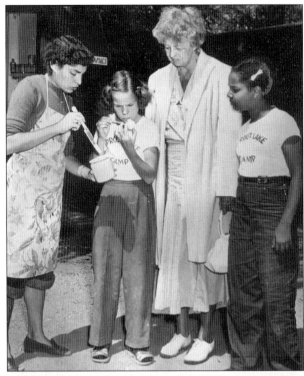

SPROUT LAKE CAMP, VERBANK. From the time Aunt Gracie had taken her to the Orthopedic Hospital in New York City founded by her grandfather, Eleanor Roosevelt was sensitive to the special needs of children who suffered from debilitating illnesses. Here, she visited a newly established camp for children with heart problems. (PJ.)

HYDE PARK 4-H. Among these 4-H girls are Mary Draiss and Mary Beth Darlington, whose father served on the St. James Vestry with Franklin Roosevelt. For 31 years Mary Draiss' father was Franklin Roosevelt's road builder and groundskeeper. At a Roosevelt Christmas party, Mary Draiss received a doll from Eleanor Roosevelt, as did her brother, who was not the least grateful; Franklin Roosevelt intervened and gave the brother a toy lawn mower. (PJ.)

DC Fair. Here, Eleanor Roosevelt admires the pigs. On other occasions she inspected her son Franklin's polled Herefords and sheep. Wandering around the fairgrounds, she was always accessible to those who wanted to say a few words to her. On the way home, she sometimes stopped for lunch at the Vanderbilt Inn, later used as the Visitors Center at the Vanderbilt National Historic Site. (PJ.)

With Her Granddaughter Sally. In the typical pose of a grandmother, Eleanor Roosevelt is tying a bow for the little girl standing there patiently. Shortly after this time, the girl's family moved to Stone Cottage at Val-Kill. Her father, John Roosevelt, gradually accumulated what remained of the land in Hyde Park, which his brother Elliott Roosevelt had operated as a farm with his mother. (Photograph by Dr. A. David Gurewitsch.)

BIRTHDAY PARTY. After John Roosevelt's family moved into Stone Cottage, Val-Kill replaced Springwood as the destination for children and grandchildren, nieces and nephews. Eldest daughter Nina describes it as "a summer camp atmosphere" all the time. She also remembers birthday parties like this for her brother Haven, with their mother and sister "Joanie" and guests, as well as summer picnics and sleepovers that left little time for sleep. (Photograph by Dr. A. David Gurewitsch/NRG.)

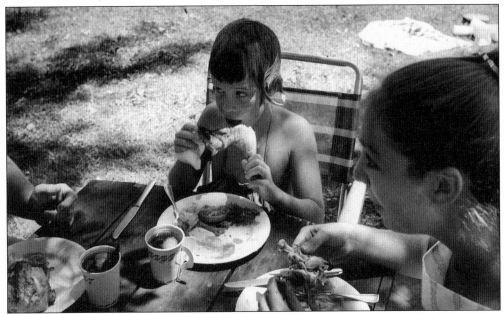

NANCY ROOSEVELT AND CHICKEN LEG. Grandchildren, nieces, nephews—everyone whom Grandmère brought into the circle has memories of her. Gnawing on a chicken leg or having afternoon tea or listening attentively at "storytime" were special times. Grandmère made everyone family and Val-Kill Cottage a dormitory for young people, family or not. (Photograph by Dr. A. David Gurewitsch/NRI.)

LITTLE PRINCESSES. Despite the scowl, children—whether royal or from the Wiltwyck School (an interracial residential treatment center for troubled youth)—usually enjoyed Val-Kill picnics. Once when Eleanor Roosevelt was asked why she was personally buttering the rolls for the Wiltwyck boys, she replied that they had as much right to butter as anyone, a sentiment undoubtedly shared by the down-to-earth Dutch royal family. (NPS.)

QUEEN JULIANA IN KINGSTON. On the rostrum to greet the queen, mother of the princesses, when she came to celebrate the 300th anniversary of Kingston in 1952 was Eleanor Roosevelt. Following the ceremonies, the queen was the overnight guest at Val-Kill. Both Roosevelts were proud of their Dutch heritage. (FOHK.)

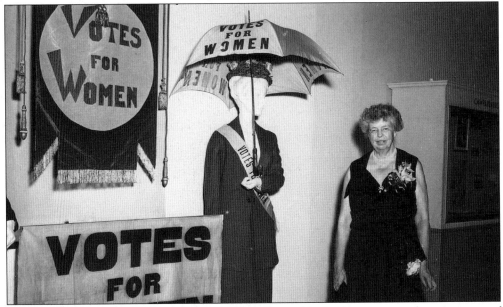

AT THE NEW-YORK HISTORICAL SOCIETY, NEW YORK. Having become an ardent supporter of women's suffrage, Eleanor Roosevelt had not been at all pleased when women were kept waiting outside the door while men wrote the Democratic party platform in 1924. Throughout her life, she emphasized the need for women to play important roles in the political process. In 1928, it was their organization that contributed to her husband's victory for governor. (FDRL.)

NATHAN LIEBERMAN. Now a retired physician, Nathan Lieberman still remembers his commencement at Poughkeepsie High School in 1951. It was a special day for him, as he was valedictorian and Eleanor Roosevelt the speaker. In her "My Day" column shortly thereafter, Eleanor Roosevelt noted that often neither their elders nor their schools prepared students well to meet the challenges they would encounter. She always stressed the need for critical thinking. (NL.)

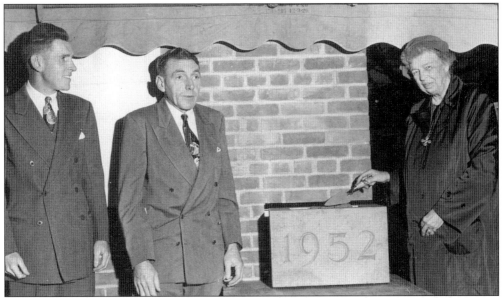

DEDICATION OF LLOYD TOWN HALL. With trowel in hand, Eleanor Roosevelt made historic the occasion of the dedication of the new town hall. A town on the west shore of the Hudson, Lloyd was another of the many small places she visited and where she got a feel for the everyday life of its residents, enabling her to speak and write on issues of concern to them. (PJ.)

WITH DR. VLADIMIR SIMKHOVITCH. Throughout her life, Eleanor Roosevelt remained interested and involved in programs she supported. Having early come into contact with Mary Simkhovitch, the founder and director of Greenwich House in Greenwich Village, she was also at hand in 1952 to celebrate its 50th anniversary. She credited Mary Simkhovitch with focusing attention on the complexity and interrelatedness of urban problems. (PD/AS.)

NEWBURGH, 1952. Eleanor Roosevelt came to celebrate Newburgh's designation as an All American City. Oliver Winstanley, a young fireman at the firehouse on lower Broadway, recalls that the former First Lady had driven herself to town in a little coupe and wore a "homely" cloth coat. Winstanley recognized her, and he rushed over to walk her to her destination. He remembers how graciously she complimented Newburgh and thanked him. (HSNB&H.)

THE COHEN FAMILY, 1953. Doris Darlington Cohen of Hyde Park and her husband, Walter Cohen, whose family had escaped from Nazi Germany, went to services at St. James' Church when he came home on leave from the army during the Korean War. At the end of the church service, Eleanor Roosevelt "swooped" down the aisle from her pew at the front, grasped Walter's hand, and said, "I never miss an opportunity to shake the hand of a man in uniform." (W&DC.)

JEAN FRANCES COOPER. A second-generation native of Dutchess County, Jean Frances Cooper met Eleanor Roosevelt while they were both shopping at the Grand Union on Washington Street, according to son Tom Cooper's recollections. This chance encounter was not unique, as Eleanor Roosevelt enjoyed these excursions. Jean Cooper also liked to watch Mrs. Roosevelt on television as a guest on the *Sam Levinson Show.* (THC.)

AMERICAN ASSOCIATION FOR THE UNITED NATIONS BIRTHDAY PARTY. After his election as president, Dwight D. Eisenhower accepted Eleanor Roosevelt's resignation from the American delegation to the United Nations. She immediately went to the offices of the American Association for the United Nations and volunteered to organize support for the United Nations. Estelle Linzer, her assistant, recalled her practical streak: she always wanted to know how much money various fund-raising efforts had netted. (FDRL.)

VAL-KILL. Eleanor Roosevelt was a world traveler. Still, she was always happy to come home to Val-Kill in the spring to see daffodils blooming. In June, she enjoyed picking rhubarb in the garden and eating fresh asparagus. In August, she remarked on the goldenrod and the wildflowers that were blooming in profusion. When she had guests, she personally arranged flowers for their rooms. (NF.)

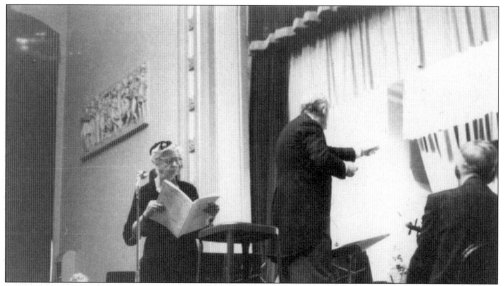

Peter and the Wolf, POUGHKEEPSIE. This 1956 performance by the Dutchess County Philharmonic, conducted by Ole Windingstad, was presented free to children of county schools and sponsored by the Federation of Musicians, Local 238, the Philharmonic Society, and the Junior League. Eleanor Roosevelt served as narrator. Long a believer in the importance of the arts, she had helped create the Federal Writers, Artists, Music and Theatre Projects in 1935. (BOH/HVPA.)

MARK ADAMS ON HIS FIRST DAY OF SCHOOL.
Mark Adams, now a noted horticulturist, had
an enterprising mother, Doris Adams, who,
in need of a program speaker simply wrote to
Eleanor Roosevelt to invite her to a parents
meeting at Ralph R. Smith School, very near
Val-Kill. Eleanor Roosevelt accepted and was
so gracious that everyone was very pleased
by her presentation. If only the enterprising
mother had taken a photograph. (DA.)

MEMORIAL DAY, TIVOLI. Bill Brown (left) invited Eleanor Roosevelt to speak at the 1956
Memorial Day ceremonies. He remembers her as being very low-key and charming. She was
accompanied by just one person who functioned as both an aide and her driver. We can only
imagine the noise—perhaps some guns going off—that led her to put her fingers in her ears
while still smiling broadly. (WB.)

JANET BRAUN AND FRANK MARCHESE, ELLENVILLE. Janet's father, John C. Braun, supervising principal, invited Eleanor Roosevelt to be the 1957 commencement speaker and also invited her to dinner. She accepted, and he picked her up in Hyde Park, having said to his wife, "Guess who's coming for dinner!" After the simple dinner and the commencement, the Brauns drove their guest home. Frank Marchese, class vice president, was not included at the dinner but later married Janet Braun. (F&JM.)

JOHN FLANAGAN, 1957. Now senior copy editor for the *Poughkeepsie Journal*, John Flanagan recalled that when he was in Millbrook Elementary School, the children used to go to the high school on Friday afternoons to see a movie or a puppet show. One Friday, Eleanor Roosevelt was the program, and Flanagan remembered his great disappointment at seeing an "elderly lady with a funny voice." He added, "I just didn't realize it was history!" (JF.)

GARY LINDSTROM. In the first graduating class from Dutchess Community College, Gary Lindstrom, who was on the Student Council, still remembers meeting Eleanor Roosevelt and hearing her speak. As usual, she came without an entourage, accompanied by only one person. Education was always a top priority for her, so she was especially pleased to be at the college, the result of county residents' desire to establish a local college. (GL.)

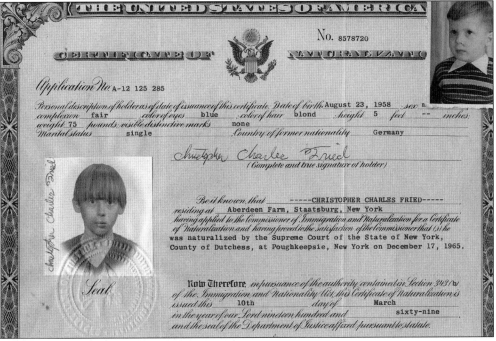

CHRISTOPHER FRIED, STAATSBURGH. His father, Art Fried, first met Eleanor Roosevelt when he sold her a car. Florence became engaged to Fried on the day she met Eleanor Roosevelt. After the war the Frieds adopted two German children, a lengthy process requiring Florence Fried to spend more than a month in Germany. When the former First Lady learned in 1957 of their plans to adopt a third child, she wrote to the German ambassador. Christopher was theirs in three days. (FF.)

GRANGE AWARD. Having joined the Chapel Corners Grange on December 28, 1931, Eleanor Roosevelt received an award for 25 years of membership. Franklin Roosevelt received his 25-year certificate in 1939. Both Roosevelts attended and spoke briefly at the 50th and 60th anniversary celebrations of this Grange. According to material prepared by longtime Grange leaders Agnes H. Bahret and Sidney Kessler, the Roosevelts were "a very amicable and unpretentious couple." (PJ.)

TI YOGI BOWMAN AWARDS. "Tubby Curnan" (second from the right), a longtime member of the organization, was Eleanor Roosevelt's driver for a number of years. They were often seen driving around town in a small Fiat, purchased while her son Franklin Roosevelt had a Fiat franchise. It was perhaps in response to Curnan's invitation that Eleanor Roosevelt attended this dinner, where Dorothy and Charles Hughes (left) were honored. (RHG.)

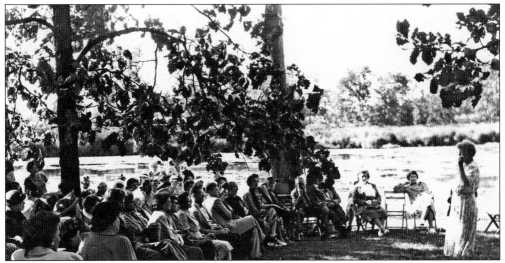

ROOSEVELT HOME CLUB CARD PARTY, VAL-KILL. While the club was "nonpartisan" and Eleanor Roosevelt helped people of any persuasion, she was also active in Democratic politics at every level. Her support for Adlai Stevenson in his two presidential campaigns was strong and energetic, but she was also concerned about local politics and enjoyed talking to her neighbors about various issues. (PC.)

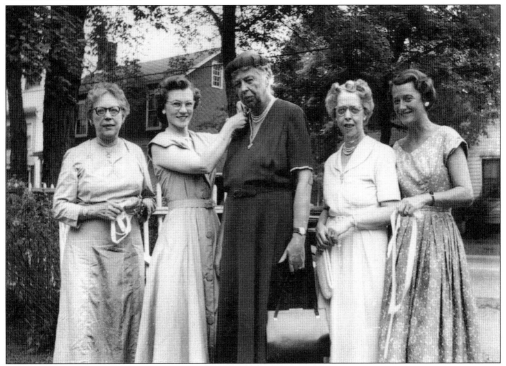

WITH HYDE PARK FREE LIBRARY ART SHOW ORGANIZERS. Seen with Marjorie Lovelace, Beverly Simmons, Claire Kidd, and Dorothy Todd, Eleanor Roosevelt was both a supporter of the arts and an avid reader. She loved to read classics aloud but also enjoyed the more modern poetry of T. S. Eliot, whose work she said demanded several rereadings. But then, she was always up to a challenge. (J&GG.)

JERRY DEYO, POUGHKEEPSIE. In the late 1950s, Jerry and Arlene Deyo were agonizing about the future of their son Kipp Deyo, who had increasingly serious health problems. They read a "My Day" column in which Eleanor Roosevelt described a school for children like their son, and this helped them decide that it would be the best place for him. Even without personal contact, Eleanor Roosevelt had provided needed information and support. (JD.)

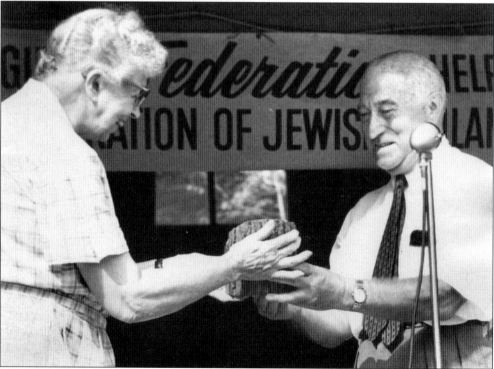

CAMP SOLOMAN, 1959. Eleanor Roosevelt, who worked tirelessly for a variety of Jewish causes and was a staunch supporter of Israel, was a "Special Visitor" to this big Jewish family camp, with separate camps for children, adults, and seniors, located in the town of Southeast on the Westchester County border. Israel Cummings is making the presentation. (WCHS.)

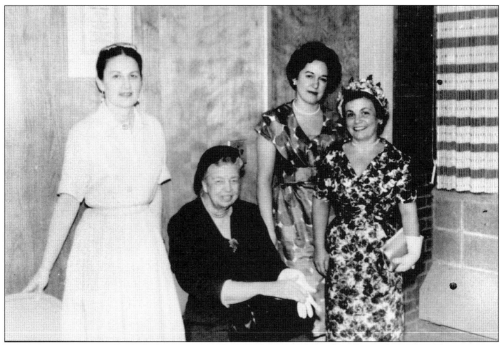

AT TEMPLE BETH-EL, POUGHKEEPSIE. Eleanor Roosevelt spoke about the United Nations at a program arranged by Rubi Goldberg, Bebe Bender, and Gertrude Tinkelman and attended by Rabbi Erwin Zimet and his wife Lilli, just before their first trip to Israel. Beforehand, as she was going to dinner next door, the former First Lady was approached by a little girl who wanted the visitor to come to her house. Eleanor Roosevelt replied that, if she received an invitation from the child's mother, she would come . . . and she did. (LZ.)

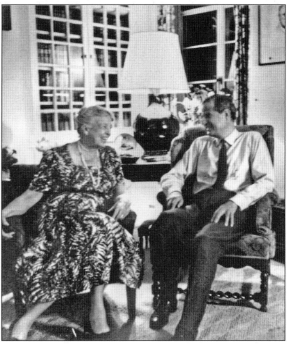

WITH DAVID GUREWITSCH, 1958. Dr. David Gurewitsch was Eleanor Roosevelt's personal physician. Close and loving friends since 1947, the two often traveled with the former First Lady's secretary and family members to places such as Russia, Israel, India, Pakistan, the Far East, and Europe; they also enjoyed the tranquility of Val-Kill. (Courtesy of Edna Gurewitsch.)

November 30, 1959

My dear Margaret:

How good you were to join in the shower given by Mrs. Kidd!

The towels are lovely and have already been used in my new apartment. Thank you so very much for your thought in giving them to me.

I'm almost settled but not quite! However, I hope to give a party on December 2nd, so things are being rapidly put in place.

With every good wish,

Affectionately,

Eleanor Roosevelt

THANK-YOU LETTER. With the Gurewitsches, Eleanor Roosevelt bought a town house in Manhattan. When she prepared to move in, it became apparent that she had little kitchen equipment. Learning that she had never been given a shower (bridal or otherwise) and was rather pleased at the idea, Claire Kidd, wife of the rector of St. James, gave her a kitchen shower. In this letter, Eleanor Roosevelt thanked Margaret Suckley for her gift. (WP.)

MEMORIAL DAY, HYDE PARK, 1959. Eleanor Roosevelt and Father Gordon Kidd greeted Lyndon Johnson with their usual kindness and courtesy. Sylvia Wilks, daughter of eccentric millionairess Hetty Green, inquiring about the state of family graves, encountered the same simple honesty Mrs. Roosevelt appreciated in Father Kidd, who responded that they were in good condition and there was no need for a contribution. In her will, Sylvia Wilks left the church over a million dollars. (FDRL.)

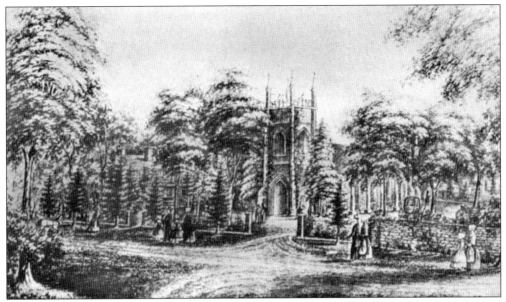

SESQUICENTENNIAL OF ST. JAMES CHURCH. This drawing was used in the 1913 book celebrating the establishment of St. James. Almost 50 years later, Mrs. James E. Spratt compiled *Historical Notes of St. James' Parish*. At the celebratory luncheon, Eleanor Roosevelt spoke about the rich traditions of the church and how much it had meant to her husband. During difficult times they both found comfort here. (GM Jr.)

ABOUT TO DANCE. In 1960, when the local American Field Service branch needed to raise money to bring students from abroad to Dutchess County, Don Marchese, student government president, asked Eleanor Roosevelt to participate. As usual, she accepted, bought her own ticket (a "share of stock" signed by Harold Spencer, chief executive officer of Western Printing), came, and danced, confessing, however, that she "didn't dance too much anymore." (DM/PJ.)

STEPHEN ROSENFELD, QUEENS COLLEGE. Seated beside Stephen Rosenfeld, the future Wappingers Falls dentist, Eleanor Roosevelt asked him to tap her shoulder when it was time for her remarks at his graduation ceremony. She then turned off her hearing aids and took a catnap. At the appropriate moment, he tapped her lightly; he tapped harder; his third nudge, almost enough to unseat her, did the trick. She turned on her hearing aids and leapt to the podium. (SR.)

COMMISSION ON STATUS OF WOMEN, 1962. Pres. John F. Kennedy appointed Eleanor Roosevelt to serve on the Commission on the Status of Women, which according to a "My Day" column, he had established because of May Craig, a very persistent newspaper woman. Eleanor Roosevelt articulated the aim of many at that time: to use the potentialities of women without hurting their first responsibilities, which were to their homes, husbands, and children—priorities that were even then evolving. (PJ.)

DUTCHESS COUNTY WOMEN'S DEMOCRATIC CLUB LUNCHEON, MAY 1962. Gerry Raker, who shared the dais with Eleanor Roosevelt at this event, remembers her voicing regret at having sent her children to private schools instead of working to improve public schools. After the successful fundraiser, the former First Lady wrote Mrs. Raker, "It is important . . . to channel [the enthusiasm] into some constructive work for the future." She suggested meeting to discuss the State Democratic organization. (GRS.)

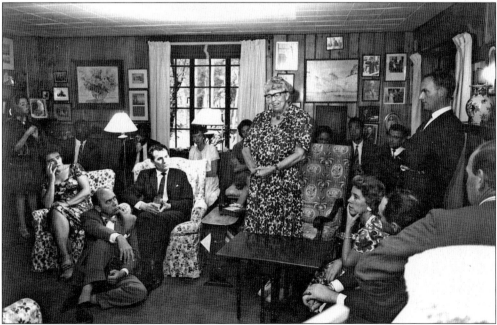

WITH BRANDEIS STUDENTS AT VAL-KILL. Always looking for opportunities to talk with young people, she welcomed speaking at local schools and colleges. And, in the early 1960s, she experimented with a new idea of doing a series of television programs in cooperation with Brandeis and teaching a course there. Just a few months before her death, she entertained students in a multinational communications seminar. (FDRL.)

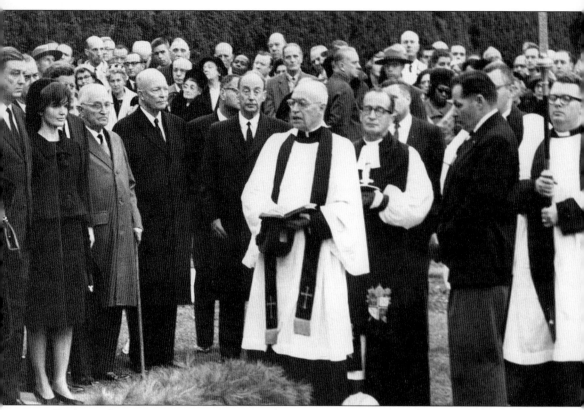

ELEANOR ROOSEVELT'S FUNERAL, HYDE PARK, 1962. Almost to the very end of her life, Eleanor Roosevelt remained actively engaged in helping individuals and organizations as well as reaching out to young people. As she said, her interest in a problem always began with a person. In her last "My Day" columns, she spoke of the need to present American ideals appropriately to new and developing nations and to concentrate on really helping them rather than on supplying arms. When she died, the mighty and the ordinary mourned, united in their respect for her honesty, friendliness, energy, and efforts to live according to St. Francis's prayer, "Lord, make me an instrument of your peace." (PJ.)

Four

MIRACLE AT VAL-KILL

When Eleanor Roosevelt died on November 9, 1962, all those inspired by her work and example mourned. Local residents wept beside family and leaders of the world at her funeral.

Although she had expressed no wishes about possible memorials, ideas from many sources focused on continuing support for her many charities. Several million dollars were raised. Efforts to make her home at Val-Kill part of the FDR National Historic Site were discouraged by Washington leaders who explained that including a First Lady in the site would be precedent setting. Finally, a portion of funds raised was devoted to building the Eleanor Roosevelt Wings on the presidential library, and the remainder was used to create the Eleanor Roosevelt Institute, a small foundation devoted initially to funding the work of her historians.

It seemed that her life's work as an advocate and coalition builder for political and social change might be only a footnote in American history. But by 1977, the context was changing: Joseph Lash's book *Eleanor and Franklin* had introduced Eleanor Roosevelt to a new generation; Jimmy Carter, a Democrat was president; and the women's movement was gaining in strength. The establishment of the Eleanor Roosevelt Center at Val-Kill (known as ERVK), which continues her work today at the Eleanor Roosevelt National Historic Site, is the triumph of her legacy and the effectiveness of her skills and her methodology: identify a problem, learn from those affected, seek out helpers, encourage peaceful discourse that proposes solutions, and work together to enact acceptable institutional resolution.

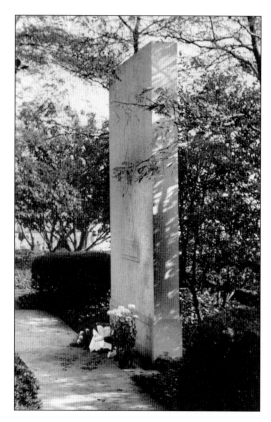

MONUMENT AT THE UN. Dedicated in 1966, this memorial to Eleanor Roosevelt is a 10-foot-high granite slab on which is written Adlai Stevenson's statement: "She would rather light a candle than curse the darkness and her glow warmed the world." In April 1963, President Kennedy signed Public Law 88-11, chartering the Eleanor Roosevelt Memorial Foundation to collect private donations to support such projects in her honor. (NPS.)

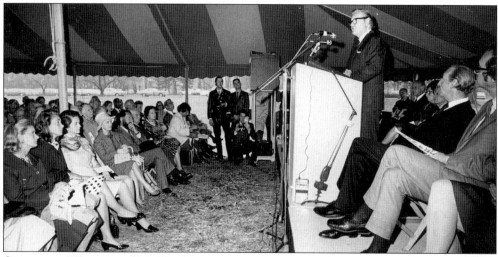

CROWDS AT ELEANOR ROOSEVELT WINGS OPENING, 1972. Funds collected were used to construct the Eleanor Roosevelt Wings of the Franklin D. Roosevelt Library, which contain the first collection of material related to the life of a First Lady to be housed in a presidential library. That same year, the Eleanor Roosevelt Memorial Foundation was terminated. Remaining funds were transferred to the Eleanor Roosevelt Institute. Val-Kill remained in private hands. Many still mourned. (PJ.)

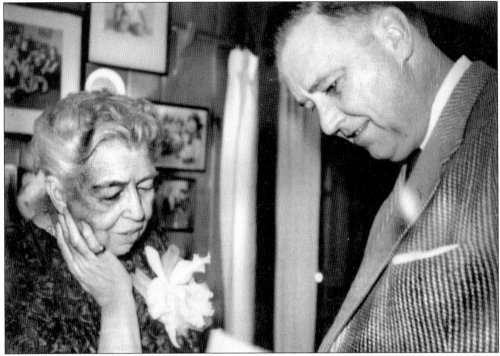

WITH SON JOHN IN VAL-KILL COTTAGE. Eleanor Roosevelt was a heroic figure to the nation and the world, but to family, her memory would always conjure up personal and private reminiscences. Her remaining relations and especially her grandchildren would miss their Grandmère and would continue to relive private times with her in "their" special places. (NRG.)

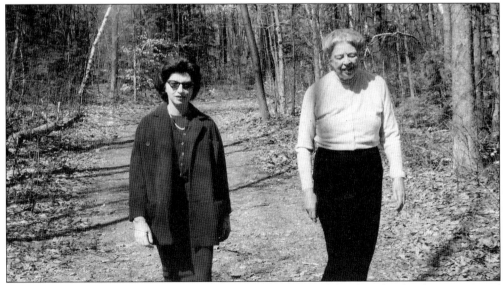

EDNA GUREWITSCH. Trusted close friends of long standing felt her loss deeply. Physician David Gurewitsch and his wife were among a circle of such confidants who shared her life intimately. Visits to Val-Kill and private times in the New York City townhouse they shared remained a personal treasure for the couple. Their walks together through Val-Kill's wooded grounds are among Edna Gurewitsch's special memories. (Photograph by Dr. A. David Gurewitsch.)

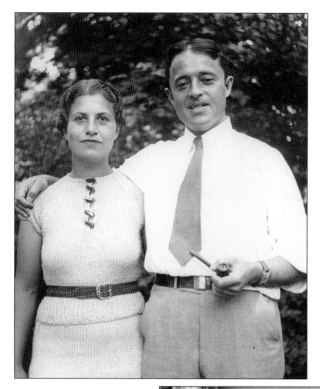

ZERLINE AND MAX SIMON.
Dr. Max Simon, a practicing
surgeon for 50 years, was a family
friend. Eleanor Roosevelt shared
his sorrow when his wife died.
Interested in education and
international affairs, he organized
in Poughkeepsie the 13th biennial
Congress of International
Surgeons. The Simons' daughter
Fredrica Goodman served as
director of the Eleanor Roosevelt
Centennial Commission and is
on the board of the Franklin and
Eleanor Roosevelt Institute. (FG.)

MILTON HAVEN.
During World War II,
many American soldiers
suffered from tension
disorders. It was found
that handwork, such as
knitting, restored their
calm. Eleanor Roosevelt
had discovered much the
same thing as a young
woman, and photographs
of her knitting are
legion. Many veterans
like Judge Milton Haven
continued to find calm
in knitting. After his war
service, Haven became a
local icon famed for his
Icelandic sweaters. (PJ.)

Maureen Corr, Holding Val-Kill Letter Holder. Eleanor Roosevelt's secretary from 1950 to 1962, Maureen Corr remembers vividly her first meeting with the former First Lady. Eleanor Roosevelt entered the room, hand outstretched, saying, "I'm Eleanor Roosevelt." Once, when Maureen Corr indicated a liking for cherry pies, the kitchen staff asked, "Who's going to pit the cherries?" The First Lady herself. Eleanor Roosevelt "lived to be kind, and to me her private image far outshone her public one," she said. (MC.)

Doris Muller Wheeler, Holding Article on a Lecture Tour with Mrs. Roosevelt. Only 18 and less than a year after graduation from Franklin D. Roosevelt High School, Doris Muller Wheeler became Mrs. Roosevelt's secretary to share some of the voluminous tasks with Maureen Corr. She spent four years working for the former First Lady and came to know firsthand the "graciousness and warmth that characterized this wonderfully intelligent human being whose caring extended to all." (DMW.)

MARY ELLA AND HECTOR COONS. Eleanor Roosevelt's death brought back almost forgotten memories to many including Mary Ella Lasher Coons. A talented seamstress from Tivoli, she shared her experience with granddaughters Sue Strom and Joann Cohen of working with neighbors on Eleanor Roosevelt's wedding dress. As the process of saving Val-Kill unfolded, such stories told to younger family members by Roosevelt's contemporaries helped them see her in a more personal light. (SCS.)

LaCLAIRE TRAVER WOOD, 1938. LaClaire Traver Wood presents a child's perspective of Eleanor Roosevelt. Wood's grandmother married Roosevelt tenant Moses Smith. Their farm, Woodlawns, was across the road from Val-Kill. Thoughtful Roosevelt presents to family and grandchildren—a piano shawl and *Heidi* book—made little neighbors welcome her visits. Wood's career as a *Poughkeepsie Journal* reporter gave more opportunities to record personal Eleanor Roosevelt memories from train trips and assignments. (LW.)

COOKING UP A STORM IN HYDE PARK. Marge and Les Entrup ruled over Val-Kill's kitchen for years, which was akin to operating a 24-hour-a-day restaurant. Eleanor Roosevelt's tastes were simple, and her guests ate as she did (unless there were special needs). Her last New York City cook, Anna Marie Steinke from Putnam, remembered the First Lady fondly as kind and considerate to all guests, friends, and staff. (FDRL.)

BENJAMIN FRANKLIN SCHOOL. Gerry Rosell was only an eighth-grader when Eleanor Roosevelt entered her life, but she always remembered it as a highlight of her youth. Many young people, now adults, have such personal memories as a result of the former First Lady's appearance at special ceremonies like this graduation. Her accessibility and approachability were the essence of good teaching. (GR.)

Exhibition and Sale

Personal Possessions
From the Estate of
Eleanor Roosevelt

September 18 to October 3, 1964

Catalogue proceeds for the benefit of the
Eleanor Roosevelt Foundation

HAMMER GALLERIES
51 East 57th Street, New York 22, N. Y.

1964 AUCTION CATALOGUE COVER.
Following settlement of Eleanor
Roosevelt's estate, the Hammer Galleries
were engaged to handle an exhibition
and auction of objects and material not
assigned in her will. From September 18
to October 3, 1964, friends, neighbors,
collectors, and the curious streamed in to
view and bid on items. Many purchasers
felt that they were protecting her heritage
by guarding a small piece connected to
her memory. (NPS.)

VAL-KILL AUCTION TENT, 1970. Son John Roosevelt's family continued in residence for
another eight years. To Nina, Haven, and Joan Roosevelt, Val-Kill was home. When the property
was sold in 1970, a second auction, handled for John and Irene Roosevelt by O. Rendell Gilbert,
removed all Roosevelt presence. (PJ.)

AGNES AND KENNETH WAGER. In the late 1960s, when Val-Kill was put on the market, local realtor Agnes Wager, shown here in an earlier photograph, was given the listing. It was marketed for several years before it was sold. New owners, interested in turning its 173 or so acres into a large nursing home, were met with resistance from local planners in a community grappling with historical renown and increased suburban growth. (RW.)

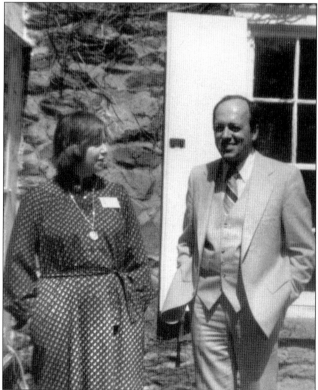

PATRICIA WAGER WEBER AND KEN TOOLE AT STONE COTTAGE. Their working relationship began in 1968–1969 with a pilot project of Cornell Cooperative Extension Service; they were part of the group that became the Hyde Park Visual Environment Committee. A first task was to identify and involve all who had a part in planning the town's future. Residents and federal government representatives began to focus on issues faced in common. (JG.)

VAL-KILL LANDSCAPE. Development near the Franklin D. Roosevelt Library and historic sites concerned both local and federal officials, but control issues weakened efforts to work together. Visitor interest kept Val-Kill before National Park Service and Franklin D. Roosevelt Library leadership; community members from the neighborhood worried about the impact on their water supply of the proposed nursing home over a major aquifer. This photograph clearly shows the site's marshy beauty. (NPS.)

XAVIER VERBECK, PLANNING BOARD CHAIR. Town planners heard cries of "No more land off the tax rolls," as a community noted for state and federal historic sites struggled with pressures for increased development. National Park Service planners saw little opportunity to add Val-Kill to the sites. The planning board's disapproval of the proposed use of Val-Kill put off all decisions for a while, leaving the site in limbo. (BV.)

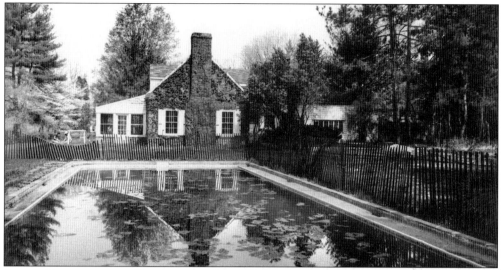

Stone Cottage from Pool, the 1970s. While awaiting delayed planning decisions, new owners turned to leasing and renting individual units within the property. Stone Cottage was leased to a Dutch IBM airline pilot and his family, who refurbished the cottage and pool, which had suffered from disuse. Other structures, which had been subdivided into apartments, and the former caretaker's house were rented. Without care, the rest of Eleanor Roosevelt's beloved grounds and gardens suffered. (NPS.)

Albert McClure's Proposed Town Seal. Stoutenburgh waterfowl and Roosevelt roses—family coats of arms—met in Albert McClure's design, which focused on early town and American history. The retired National Park Service curator from Ireland whose brogue, stories, and talents endeared him to local residents, used his museum training to provide the Normandy coast model that trained World War II invasion troops. Later, his drafting skills produced a modest miracle . . . a seal highlighting history. (JMK.)

RALPH ARLYCK. Hyde Park Visual Environment Committee sponsorship of a film by independent filmmaker Ralph Arlyck provided the vehicle to strengthen an emerging coalition. From 1973 to 1976, Arlyck's camera was on the planning process and historical assets. The committee's leadership saw town heritage as a tangible asset. A landmarks survey was an early project. The bicentennial of the American Revolution highlighted history projects and promoted cooperation with national sites. (RA.)

ROOSEVELT ROAD DEVELOPMENT, VAL-KILL MAP. The coalition was bringing the town together. Those living near Val-Kill on the town's eastern border wished to have their neglected historic site considered in any town planning. In November 1975, Hyde Park Visual Environment Committee board member Sandy Bloom's call to chair Joyce Ghee reporting a rumored visit to Val-Kill by a "state official" interested in making it a park started the ball rolling on work to save the site. (NPS.)

NANCY DUBNER, COLLEGIATE COUNCIL OFFICER, 1954. A call to Warren Hill, National Park Service superintendent, netted Joyce Ghee and Joan Spence a connection to the lieutenant. governor's "ombudsman for western New York," who would become a partner. Nancy Dubner, as a student and officer in the Collegiate Council of the UN had been invited to Val-Kill but was unable to come. She was devastated by what she saw on her visit for Lieutenant Governor Mary Ann Krupsak. (ND.)

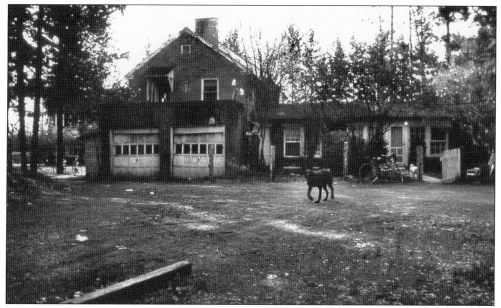

VAL-KILL COTTAGE, 1976. This view of Val-Kill Cottage, which so upset Nancy Dubner, had the same effect on Eleanor Roosevelt's grandson Curtis, a frequent Franklin D. Roosevelt Library visitor, and actress Jean Stapleton, who requested to see the site when researching a television role there. Through director William Emerson and joined by novelist Rhoda Lerman, they offered their support to the Hyde Park Visual Environment Committee in its task of gaining community support for saving the site. (LH.)

JEAN STAPLETON AND EDWINA GILBERT AT STAATSBURGH. Plans to test the waters on adding Val-Kill to Hyde Park's historic sites moved ahead quickly. With Edwina Gilbert as Hyde Park Visual Environment Committee chair, Joyce Ghee and Nancy Dubner led the Cottage Committee, supported by the Visual Environment Committee, National Park Service, Franklin D. Roosevelt Library, Cornell, and county representatives. Curtis Roosevelt and Rhoda Lerman volunteered assistance. A luncheon welcomed Jean Stapleton, the star of "Val-Kill, a Report to the Community." (LH.)

REPORT PARTICIPANTS CELEBRATE. The smiling faces of Nancy Dubner, Jean Stapleton, Lieutenant Governor Krupsak, Joyce Ghee, Ken Toole, and Curtis Roosevelt reflected the program's resounding success at the Vanderbilt Mansion reception. No doubt remained in the minds of the standing room only crowd at the Franklin D. Roosevelt High School that stormy April 1976 night that Val-Kill must be saved. Stapleton's reading of Lerman's "Soul of Iron" brought Eleanor Roosevelt back. (PJ.)

BERNARD KESSLER. With a loan of $50 from the Hyde Park Visual Environment Committee, assisted by lawyer Bernard Kessler, long a Roosevelt supporter, the Cottage Committee was incorporated in September 1976 as Anna Eleanor Roosevelt's Val-Kill, an educational corporation now known as ERVK. The board selected Curtis Roosevelt as chairman and Kenneth Toole as president and added Franklin D. Roosevelt Jr., Jean Stapleton, and Bernie Kessler to its membership. Its first assignment was to press for making Val-Kill a national historic site. (BK.)

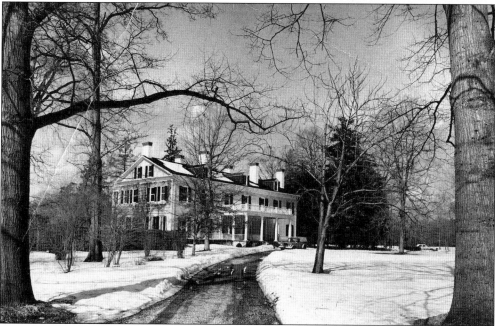

BELLEFIELD, SPRINGBOARD FOR ACTION. The new ERVK board envisioned a unique monument: Val-Kill as a living memorial to Eleanor Roosevelt. The board's goal became to support the establishment of a national historic site dedicated to continuing her work, building upon her values and methods. Bellefield, donated to the National Park Service by Gerald Morgan Jr., became its workplace. Peg Zamierowski, Hyde Park Visual Environment Committee chair, offered secretarial support with typewriter, card table, and folding chair. (GM Jr.)

THREE OFFICIALS. The first objective was to widen the circle of supporters, beginning in a community whose voting record for Franklin Roosevelt had historically been tepid. Councilmen Raymond Connelly and John Buchanan (Republicans) flanking and Supervisor J. Roger "Bucky" Golden (a Democrat) were a few of the elected and appointed town and county officials of different political persuasions with whom local ERVK board members and supporters shared their views and hopes. Eleanor Roosevelt's popularity was a plus. (JG.)

CONGRESSMAN HAMILTON FISH. Through the new chairman of ERVK, Curtis Roosevelt, the Roosevelt family and friends became part of the circle, offering homes for gatherings and access for board members and serving as door openers. Pressing for legislation, Joan Spence and Curtis Roosevelt visited valley congressmen in Washington. They found generous support from Congressman Bingham and from Hamilton Fish Jr., son of the Fish of "Martin, Barton, and Fish," the trio of naysayers often invoked by Franklin Roosevelt. (ERVK.)

HYDE PARK TOWN HALL. As a bill was drafted, the National Park Service and the Franklin D. Roosevelt Library worked with local and federal entities. Park service superintendent Warren Hill met with town, county, and regional park planners and Val-Kill and Hyde Park representatives, covering all bases. Library director William Emerson's testimony pleased and attracted residents' interest and understanding. By April 15, 1977, when a local public hearing was held, there was little doubt that support was across the board, Republican and Democrat. (JG.)

VAL-KILL DELEGATION, WASHINGTON. An enthusiastic group representing the new coalition entrained for Washington hearings in May 1977. It included government officials, Val-Kill board leadership, National Park Service administration, and enthusiastic friends. Les Hyde, Cornell Cooperative Extension staff and the treasurer of the Center at Val-Kill, took photographs. From left to right are "Bucky" Golden, Ellie Seagraves, Joan Grennan, Warren Hill, Ken Toole, Joyce Ghee, Ross Holland, and Nancy Dubner. Curtis Roosevelt's sister Ellie provided warm hospitality. (LH.)

CURTIS ROOSEVELT TESTIFIES. Grandson Curtis Roosevelt and Kenneth R. Toole, Dutchess County's deputy planning commissioner, lent moving words in support of an idea drifting in limbo for 15 years: to make Eleanor Roosevelt's home a national historic site. With witnesses like Town Supervisor J. Roger Golden, Nancy Dubner for New York State, and Jean Stapleton, who showed her filmed portrayal of Eleanor Roosevelt in *Soul of Iron*, the team won the day. (LH.)

Five

A HUDSON VALLEY TRIBUTE

The passage of federal legislation in 1977 provided a unique opportunity to create a living memorial to Eleanor Roosevelt. Val-Kill is dedicated to keeping alive and relevant today her interests and concerns, with the Eleanor Roosevelt Center at Val-Kill assuming the formidable task of institutionalizing the essence of the woman—her warmth, her intellect, her honesty, her inclusiveness, her compassion.

Anna Eleanor Roosevelt's Val-Kill (now known as ERVK) worked hand in hand with National Park Service staff at every stage of the process, as Eleanor Roosevelt would have done for projects that engaged "her considerable intellect." Together the organizations reached out to hundreds of other individuals and institutions to join in the work of rebuilding an historic setting and of continuing Eleanor Roosevelt's work in today's world, through conferences, studies, publications, and programs. This is not just a historic house, it is a dynamic museum and laboratory where her ideas and work ethic effect needed change.

The roles of both the Eleanor Roosevelt Center at Val-Kill and National Park Service continue to evolve as a partnership that allows for both visitation and focused attendance at programs and conferences that have an impact outside Val-Kill's borders. Those participating in Val-Kill programs find an openness to new ideas and the same hospitality and informality shown by Eleanor Roosevelt half a century ago.

This final chapter permits only a glance at some of the wide ranging, life-changing experiences that this small place affords.

Saving Val-Kill began as a Hudson Valley tribute, but it is becoming a world tribute.

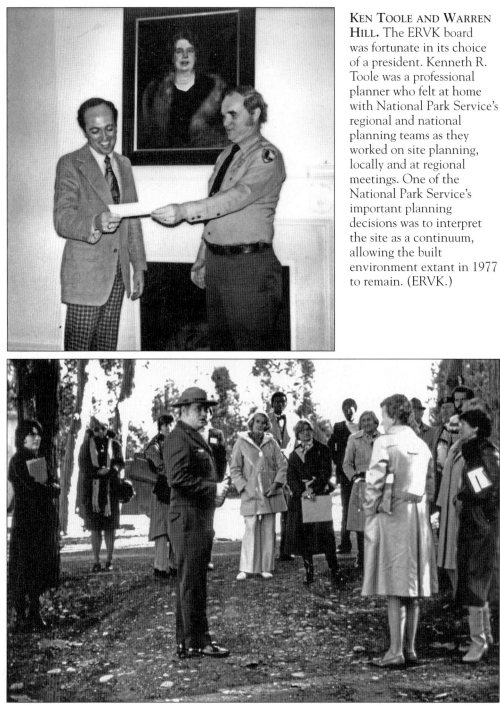

KEN TOOLE AND WARREN HILL. The ERVK board was fortunate in its choice of a president. Kenneth R. Toole was a professional planner who felt at home with National Park Service's regional and national planning teams as they worked on site planning, locally and at regional meetings. One of the National Park Service's important planning decisions was to interpret the site as a continuum, allowing the built environment extant in 1977 to remain. (ERVK.)

HOW DO WE DECIDE? As the National Park Service grappled with site planning, the ERVK board faced a monumental task in trying to decide on which of Eleanor Roosevelt's many concerns it should focus. Individuals well known in their fields of philanthropy, business, government, media, crafts, and the environment came together to advise the ERVK program committee, headed by Patricia Howe. Superintendent Warren Hill led a site tour. (ERVK.)

VAL-KILL POND, 1976–1977. With the small budget allotted by the legislation, the work to be done by the National Park Service at Val-Kill was daunting. Years of diminishing care had taken their toll. Vegetation overwhelming the pond testified to a rising water table that affected neighboring development and evidenced itself in Val-Kill Cottage's flooded basement. (NPS.)

CUTTING GARDEN. Eleanor Roosevelt loved flowers about her. An unattributed photograph from the 1970s shows the rose garden in front of Val-Kill Cottage, which she used to visit every morning to gather flowers for her apartment and the rooms of guests. By then, it was in need of care. The orchard was also overgrown, and the vegetable garden, like this rose garden, was only a weed patch. (NPS.)

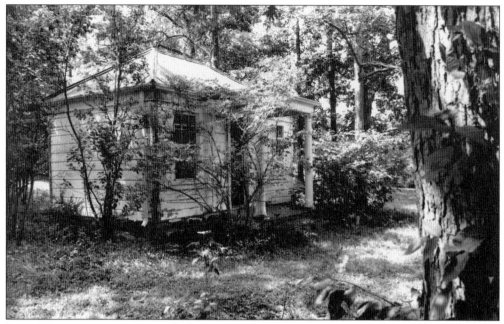

DOLL HOUSE, 1976–1977. A playhouse, moved in the 1930s at Sara Roosevelt's behest from Springwood to a promontory overlooking the pond, typified Val-Kill conditions. Overgrowth, leaks, peeling paint, dirt, and insect and small animal litter marred the scene of joyfully remembered childhood fantasies of Roosevelt children, grandchildren, and little guests of the past. The swing set nearby was being used as an outdoor clothesline. (NPS.)

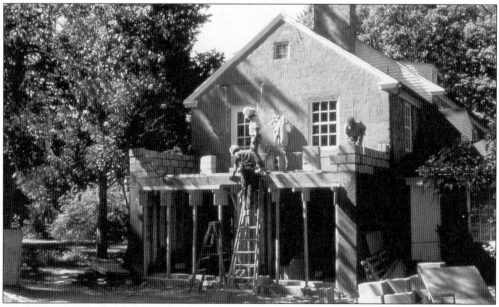

VAL-KILL COTTAGE UNDER RESTORATION. Myriad long-standing problems were addressed efficiently and with careful enthusiasm by National Park Service staff who documented every step of the way. They took pride in restoring Eleanor Roosevelt's beloved cottage from what it had become: little better than a suburban slum. The work to be done both outside and inside was immense, but it had begun. (NPS.)

RESTORED CUTTING GARDEN. After years of being neglected, it was necessary to start all over again with the garden, beginning with historical research. The physical digging and planting were rewarded at last by green sprouts that have flourished, producing blossoms like those that brightened the rooms of Eleanor Roosevelt's cheerful, homey cottage. (NPS.)

MOVING-IN DAY. The successful results of years of documentation, research, solicitation of gifts, conservation, and careful planning show in the smile on Ranger Dot Burson's face. The sturdy bed frame that she carried and other furniture would provide a welcoming presence in Val-Kill Cottage. (NPS.)

BIRTHDAY PARTY. While the property was being restored and programs were being planned and taking place, the Eleanor Roosevelt Center at Val-Kill and the National Park Service as partners celebrated Eleanor Roosevelt's October birthday. Shown here are Margaret Partridge, National Park Service site manager, and Joan Spence, the first ERVK executive director, cutting the 1979 cake at the party held at Bellefield. (ERVK.)

PARK RANGERS. From left to right are Franceska Macsali, Jean Quimby, Dot Burson, Emily Wright, and Margie Roumelis. Eleanor Roosevelt's story attracted two of these women, who initially came here through ERVK. Later recruited by National Park Service, they made careers as rangers. Franceska Macsali Urbin, a young teacher, volunteered with the ERVK Friends group. Emily Wright was hired by ERVK to research and write a report used by it and National Park Service to plan craft and craftsmanship programs. (NPS.)

LEADERSHIP TRAINING.
Two of Mrs. Roosevelt's
concerns—women and
unions—were spotlighted
at this early Val-Kill
conference. Under the
leadership of Nancy
Perlman and Linda Tarr
Whelan of the Center for
Women in Government
and with Eleanor
Roosevelt as a model,
women correctional
officers, administrators,
and facilitators explored
together various issues
they had in common. (JS.)

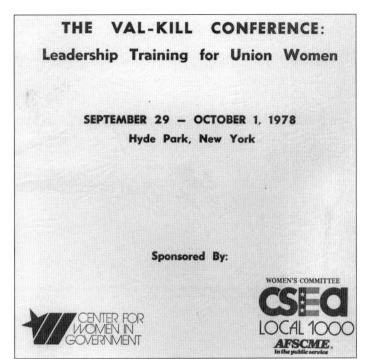

THE VAL-KILL CONFERENCE:
Leadership Training for Union Women

SEPTEMBER 29 — OCTOBER 1, 1978
Hyde Park, New York

Sponsored By:

CENTER FOR WOMEN IN GOVERNMENT

WOMEN'S COMMITTEE
CSEa
LOCAL 1000
AFSCME.
in the public service

ELEANOR ROOSEVELT: WOMEN AND WORK—IMPLICATIONS FOR THE '80S. This panel discussion, held at the Franklin D. Roosevelt Library, brought together Nancy Perlman of the Center for Women in Government, Marque Miringoff of Vassar College and author of research report on the status of women, and Charles Haspel of IBM. Today, the Eleanor Roosevelt Center at Val-Kill collaborates with the Women's Action Coalition in Dutchess County. (JG.)

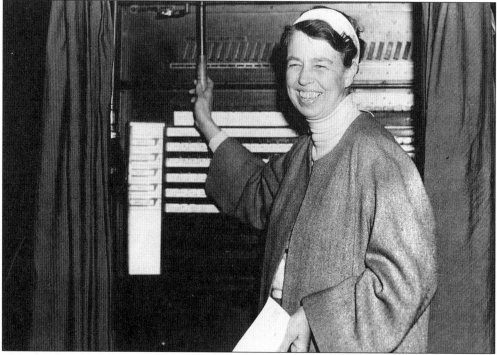

VOTING IN HYDE PARK, 1936. A continuing passion of Eleanor Roosevelt was her belief in democracy. As she said, "[It] is not a spectator sport." From the time of her early involvement with the League of Women Voters, she had learned the importance of conveying information simply and succinctly. She credited the league for its work on informing voters on issues, knowing that democracy depends upon an informed electorate. (FDRL.)

YOUR VOTE MAKES A DIFFERENCE. An early conference, organized by ERVK in cooperation with the League of Women Voters, focused on youth and citizenship. County high-school students came to discuss the issues at Val-Kill, which was in the process of restoration. One young woman marveled at Eleanor Roosevelt's bedroom, saying with surprise, "This is simpler than my own," to which her guide replied, "Yes, and she could have lived anywhere in the world!" (ERVK.)

HOT DOGS. Continuing Mrs. Roosevelt's tradition of friendly hospitality, conferences with young people usually featured food including hot dogs, of course. Adults quickly learned that often more is accomplished while munching on a hot dog than sitting around a table. The goal was always to encourage young people to speak out and to treat their ideas with the dignity and respect Eleanor Roosevelt showed them. (ERVK.)

YOUTH AND ETHICS. In cooperation with the Eleanor Roosevelt Institute, the Eleanor Roosevelt Center at Val-Kill sponsored a weekend conference at Val-Kill that brought together middle-school students from Nantucket and from New York City. The students discovered that in some ways they were very different, yet in others, similar. As Eleanor Roosevelt had been able to go beyond the boundaries of her own background, so, too, these students began to explore unfamiliar worlds. (ERVK.)

SLUMBER PARTY. At the beginning of the evolving relationship between the National Park Service and the Eleanor Roosevelt Center at Val-Kill, permission was given for students at the Youth and Ethics Conference to spend the night in Stone Cottage. While adult volunteers kept at least one eye open, students talked and laughed and broke down some of the barriers between them. (ERVK.)

CONFERRING AT VAL-KILL. In the early 1980s, elementary school reading specialist Brianne Seipp (right) spent her sabbatical as the executive director of ERVK. Seated on a Val-Kill chair and working at a Val-Kill table, she is seen with Peg Zamierowski, whose various roles have included volunteer, secretary, board member and president, and executive director. She received the Val-Kill Medal in 1997. (ERVK.)

THE FRIENDS, THE "HEART" OF ERVK. From the very beginning, while the ERVK board was organizing and sponsoring programs, the Val-Kill Friends, a group of community volunteers, kept the heart beating of this living memorial to Eleanor Roosevelt. Seated around a table at Bellefield before the Val-Kill site was even opened, the group worked hard to keep the community involved in the various happenings and to make sure that the Roosevelt warmth continued as a legacy. (ERVK.)

GLORIA GOLDEN. Pictured with Peg Zamierowski is Gloria Golden of the Val-Kill Friends, the daughter of Father Gordon Kidd, longtime rector of St. James and friend of Eleanor Roosevelt. With her husband, John Golden, she is a tireless volunteer for community and church projects. Like Eleanor Roosevelt, she is always willing to do whatever work is needed, from being the hostess to cleaning up afterwards. (ERVK.)

MARGE ULRICH. No one who came to any function at Val-Kill and was greeted with open arms by Marge Ulrich will ever forget her. Her warm welcome made everyone feel at home, whether famous like Harry Belafonte ("What you need is a hug," she told him) or a family simply enjoying a walk. Here she is at the annual Val-Kill Friends–sponsored brunch, at which many shared their memories of Eleanor Roosevelt. (ERVK.)

RUTH SHULMAN. In 1942, Ruth Shulman, the first in her family to attend college, was graduating from Hunter. Her proud grandmother came to attend the ceremony but had no ticket. Outside the auditorium she encountered Eleanor Roosevelt, the speaker, and told her. Eleanor Roosevelt immediately took her by the hand and seated her on the stage beside her. You can imagine Ruth Shulman's surprise. An active Friend, Shulman also served on the ERVK board. (RS.)

ERVK LEADERS MEET THE PRESS. At the Roosevelts as Communicators, a symposium hosted by the ERVK Friends, are seen Peg Zamierowski, assistant director, and Eleanor Charwat, ERVK president, with Anne Cottrell Free, a member of the press corps during the Roosevelt years. Eleanor Roosevelt's successful relationship with the women of the press began when she arranged a meeting with those not permitted to join the gentlemen of the press in White House sessions. (JG.)

HENRY CASSIDY, AP FOREIGN CORRESPONDENT. Henry Cassidy spoke on "Journalists as Historians." In retirement, this Chevalier De France and head of the European Bureau of Associated Press during World War II moved to East Fishkill and was appointed its town historian. His perspective was broad, his judgment fair. To him, daily news reporting was simply not the same as the in-depth assessment of information gathered over time by a historian. Case closed. (JG.)

111

CANDLELIGHT AWARDS. The Women's Press Corps in Washington, which had created a candlelight award, allowed the Eleanor Roosevelt Center at Val-Kill to take over the award. Two years later the ERVK Friends took on this program to honor members of the community who have contributed significantly to its betterment. Shown here are recipients Doris and Ralph Adams (on the left), generous business owners. (ERVK.)

HERE COME THE JUDGES. Several ERVK Friends programs have become annual events. Judge Albert Rosenblatt often reads the Declaration of Independence at the Fourth of July New Citizens program or assists at naturalization ceremonies. This occasion brought together two members of the bench, Rosenblatt and Judge Haven. Seated behind them are Julie Rosenblatt and Herb Saltford, Eleanor Roosevelt's florist, an old acquaintance and White House guest. (AR.)

WELCOMING DR. JAMES HALL, FIRST PRESIDENT OF DUCHESS COMMUNITY COLLEGE. In 1957, as the Halls moved into their Dutchess Community College residence to prepare to open the new college, their first caller was Eleanor Roosevelt. By the time the first class graduated in 1959, she was an old friend of both faculty and students. (RR.)

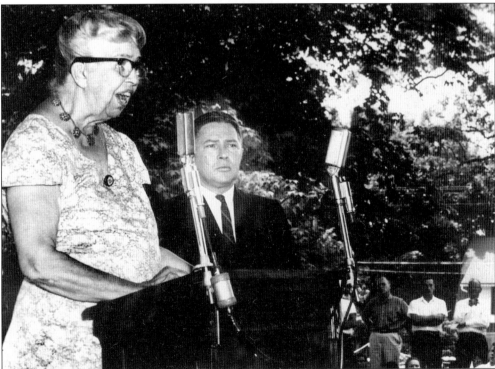

AT NEW PALTZ. Eleanor Roosevelt was a welcome visitor at all Hudson Valley schools and colleges, often as a guest speaker at conferences, colloquia, and ceremonies. Educator to the core, her experience in the field made her their advocate. These New Paltz graduates will never forget her or her message. The Eleanor Roosevelt Center at Val-Kill continues to address college needs and to include faculty and students in their programs. (PJ.)

THE REVEREND JAMES ELLIOTT LINDSLEY. This Bard graduate has long been a trusted resource for students of Hudson Valley and Roosevelt history. St. Paul's in Tivoli, his parish from 1969 to 1992, was the church of Eleanor Roosevelt's family, whose members are buried in its graveyard. Requested by the Eleanor Roosevelt Center at Val-Kill and Vassar to assist with a joint conference, the Reverend James Elliott Lindsley and his wife, Barbara Lindsley, were generous with information and hospitable to a busload of history enthusiasts. (JG.)

JANE PLIMPTON PLAKIAS. Seen here with a 1941 copy of the *Vassar Miscellany News*, Jane Plimpton Plakias remembers that exciting summer when she and about 30 other students attended a student leadership institute at Campobello, the Roosevelt home in Maine. A member of the Vassar class of 1942, she recalls that, as president of the Political Association, she was conducting a meeting when Eleanor Roosevelt slipped quietly into the back of the room, sat down, and started knitting. Jane Plakias is an ERVK board member. (AC.)

114

SITE OPENING, 1984. Seven years after the legislation was passed, the site was opened on the weekend of Eleanor Roosevelt's birthday in October. It was a grand celebration that brought together Roosevelt family members, Eleanor Roosevelt Center at Val-Kill volunteers and supporters, and all those who cherished the memory of a great humanitarian and activist. The Franklin D. Roosevelt High School band played, and visitors wandered freely through the grounds, which the National Park Service had nearly completed restoring. (NPS.)

GOV. MARIO CUOMO. Guests were treated to the thoughts of many dignitaries, including county executive Lucille P. Pattison, paying homage to the Eleanor Roosevelt's work and example. Mario Cuomo, the New York State governor, was the main speaker. Eleanor Roosevelt's children and grandchildren were honored and introduced. Nina Roosevelt Gibson, president of the Eleanor Roosevelt Center at Val-Kill, spoke passionately of her grandmother's love for the site and of her own hopes for its future as a tribute to Grandmère's work. (NPS.)

JEAN STAPLETON AS ELEANOR ROOSEVELT. To celebrate Eleanor Roosevelt's 100th birthday, the Dutchess County History Department partnered with the Eleanor Roosevelt Center at Val-Kill, the National Park Service, and the Franklin D. Roosevelt Library to reenact the 1939 visit of the English royal couple. "ER" arrived with "FDR" and the "royals" in a motorcade of vintage cars at Springwood after a stop at St. James Church. An enthusiastic audience greeted her delivery of Rhoda Lerman's script on world peace. (ERVK.)

EILEEN HAYDEN AS ELEANOR ROOSEVELT. The Fourth of July Hyde Park parade featured a short reenactment of the royal motorcade featuring ERVK Friends Eileen and Ben Hayden as Eleanor and Franklin Roosevelt. The gown made for Jean Stapleton fit Eileen Hayden perfectly. Unfortunately, there could be no stop at St. James, as a fire had destroyed the sanctuary (later fully restored). (ERVK.)

PUBLIC LECTURE SERIES. Dr. William Emerson, known for his scholarship and wit, was always a popular speaker. Ray Lafever, ERVK's Public Lectures chair, invited him and others to participate in this series, designed to interest and inform the public. The talk of Vassar professor M. Glen Johnson on the United Nations would undoubtedly have pleased Eleanor Roosevelt, as she believed passionately in educating ordinary citizens about foreign affairs. (FDRL.)

TOM COOPER. This Poughkeepsie native who started his career in local radio put his talents to work for the New York State Martin Luther King Jr. Commission. A speaking engagement at the ERVK Public Lectures program in the mid-1980s brought him into a productive partnership with the Eleanor Roosevelt Center at Val-Kill, which joined the complementary values and goals of Martin Luther King and Eleanor Roosevelt. (JS.)

Marilyn Brown at Stone Cottage. Marilyn Brown sliced fruit for the Jean Stapleton reception, bought lamps for Stone Cottage, supported a shy young weaver at a conference, maintained Stone Cottage as a center for the Children of War, and simply did whatever needed to be done. During her tenure as executive director, the conference entitled Eleanor Roosevelt and the Arts, guided by Elayne Seaman, also took place. (JS.)

Children of War. With the help of Tom Cooper and the sponsorship of the Eleanor Roosevelt Center at Val-Kill, this dynamic program led by Dr. Paul Meyer brought teens from war-torn nations around the world to the valley where they visited schools, colleges, and Albany governmental leadership to share their moving stories. The ERVK and the office of the Dutchess County Historian shared the work of planning the itinerary for these young advocates for peace with County Youth Bureau's Vicky Best and Pete Seeger and wife Toshi. (ERVK, NA.)

HARRY BELAFONTE AT VASSAR. Chair of the Martin Luther King Jr. Commission, performer Harry Belafonte joined with the Eleanor Roosevelt Center at Val-Kill staff, folksinger-songwriter Pete Seeger, Gretchen Reed, and the Children of War to lead a gathering of 2,000 students from valley schools in Vassar's huge chapel. It was the start of youth programs in area schools to help students understand the importance of working together for a world where conflicts can be settled peaceably, humanely, and fairly. (THC.)

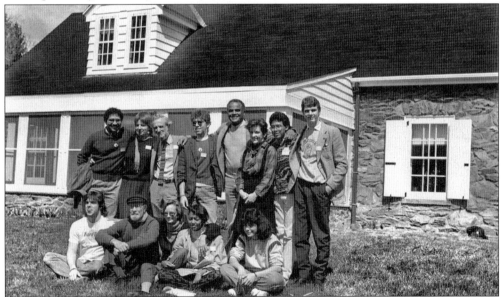

CHILDREN OF WAR, FAREWELL. At the end of their successful tour, participants and mentors celebrated together at Stone Cottage. Young people from Haiti, Northern and Southern Ireland, Israel, and Palestine, and Native Americans and Central Americans who had overcome the suffering caused by war were a new breed of future leaders. Pete Seeger (seated) Paul Meyer, and Harry Belafonte (standing) took pride in their "children." (ERVK/NA.)

DICK WAGER AS MODERATOR. Working with *Poughkeepsie Journal* publisher Dick Wager, the Eleanor Roosevelt Center at Val-Kill staff, and Tom Cooper used a 21st-century electronic format to hold a town meeting to explore ways in which the media could help heal communities coping with racism. Several hundred interested citizens attended the session and provided instant feedback to serious questions. (DCHS.)

ALEXA FISH WARD AND JOHN WOLF. Speaking at the annual meeting of the Dutchess County Historical Society is Alexa Fish Ward, daughter of Congressman Hamilton Fish Jr. In the late 1980s, she became the executive director of the Eleanor Roosevelt Center at Val-Kill. With Angela Stultz, her able assistant, Ward began immediate implementation of the program Enhancing Racial Harmony. As an outgrowth of Tom Cooper's Roots of Racism, the program was an effort to ameliorate racial tension in five areas: education, justice, housing, employment, and the media. Focus groups looked for practical solutions to problems stemming from negative racial attitudes. (ERVK.)

YOUTH AGAINST RACISM, ARLINGTON ELEMENTARY SCHOOL. Inspired by the Children of War, Youth Against Racism was established to provide an opportunity for high school students to recognize and examine prejudice in all its forms in their daily lives and to become empowered to act against it. Guided by teachers such as Sue Ciani, Gwen Higgins, and Al Vinck, the students decided their own approaches to the problems they defined. One original outreach effort to elementary school students (pictured) involved the presentation of skits they developed to show the importance of accepting people who are different. Students also produced radio and television public service announcements. And, at a time of unrest at Fort Drum, Youth Against Racism representatives traveled there to explain the program and its use as a model. Several months later, five Fort Drum students then visited Dutchess County. Many of the program participants throughout the years continue to be active. One, now a teacher, has started his own Youth Against Racism group. The YWCA took over coordination of the program, which operated in most of the county high schools. (SC.)

VAL-KILL AWARDS. The year 1987 marked the 10th anniversary of the Eleanor Roosevelt Center at Val-Kill and the inauguration of the Eleanor Roosevelt Val-Kill Medal. Designed by Elayne Seaman, the medal honors area, national, and world figures for contributions to society that reflect Eleanor Roosevelt's values. Among the first recipients was young Trevor Ferrell, whose work brought the plight of the homeless to public attention. Performer Harry Belafonte, actresses Celeste Holm and Jean Stapleton, and John Mack Jr. (CEO of Central Hudson) also received medals that year. (ERVK.)

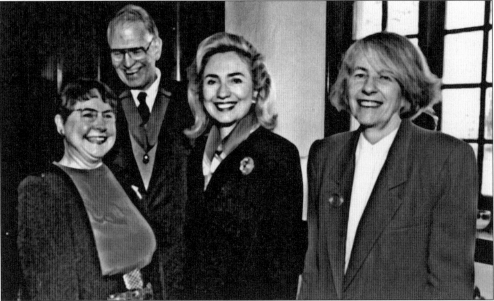

FROM ELEANOR ROOSEVELT TO HILLARY RODHAM CLINTON. Val-Kill Medal ceremonies are an eagerly awaited annual fall event, attracting hundreds of Eleanor Roosevelt Center at Val-Kill supporters and Eleanor Roosevelt admirers. Honoree Hillary Rodham Clinton, like Eleanor Roosevelt, is an outspoken human rights advocate. Congressman Hamilton Fish Jr., a past recipient and representatives of the founders, Joan Spence and Joyce Ghee, added congratulations. It is always a thrill to see the work of friends and neighbors honored. (ERVK.)

VISIT TO ALBANY. Linda Faber (left) appears with Gail Shaefer, secretary of state; Joyce Ghee; Eileen Hickey, assemblywoman; and Pat Lichtenberg, executive director of the Eleanor Roosevelt Center at Val-Kill. As director of Youth Against Racism from its beginning, Linda Faber successfully found funding from private sources, as well as from the New York State Assembly, with the help of Eileen Hickey. (ERVK.)

GIRLS LEADERSHIP WORKSHOP. The young woman seems to be making her point firmly, while others listen attentively at a session of the Girls Leadership Workshop, a program to promote women's empowerment nationally and internationally. The informality of Val-Kill allows for lively give and take. Started in 1997, while Dan Strasser was executive director, Girls Leadership Workshop helps to develop confidence and leadership skills, as well as commitment to citizenship and participation in the wider community. (ERVK.)

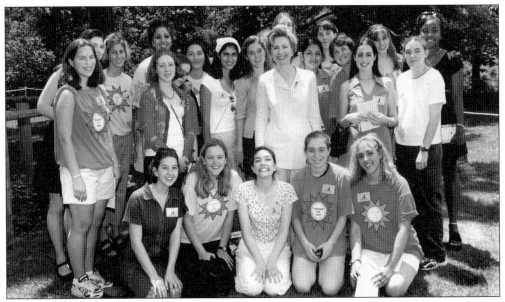

SAY CHEESE. Chosen among applicants from every state and the Commonwealth of Dominica, 30 young women participate in each of two sessions offered annually. Eleanor Roosevelt serves as a role model, and notable women of today interact with the participants, showing what women can indeed accomplish. Several reunions have already been held, but this one was special as it included Hillary Clinton. (ERVK.)

HOLLIS SHAW AND THE DIVERSITY COALITION. Having served on the steering committee of Enhancing Racial Harmony, Hollis Shaw took the program several steps further. Many of the issues redefined in earlier focus groups have found homes in the programs of social agencies such as those of the Family Partnership. Shaw continues to be a voice for racial understanding and fairness. (ERVK.)

NANCY DUBNER AND STUDENTS. Retirement for another ERVK founder, Nancy Dubner, meant developing and administering the Mohawk Valley Institute for Learning in Retirement. In 2003, she returned with a busload of her students for a grand tour of Val-Kill. Senior and Elderhostel visitors, who recall Eleanor Roosevelt's era and impact, fully understand and appreciate the very special experience that Val-Kill affords them. (JG.)

The Eleanor Roosevelt Encyclopedia. The publication of this volume was the subject of a panel discussion held at the Franklin D. Roosevelt Library. M. Glen Johnson, Vassar professor, a longtime board member and president of the Eleanor Roosevelt Center at Val-Kill, and colleague Miriam Cohen listened to Maurine Beasley, an editor of the *Encyclopedia*, who spoke about the work. It is designed to be an introduction to Eleanor Roosevelt and her world. (ERVK.)

VAL-KILL AND PARK SERVICE LEADERS, LATE 20TH CENTURY. The partnership continues: the Eleanor Roosevelt Center at Val-Kill, with its board and Elayne Seaman as chair, focuses on ways to apply Eleanor Roosevelt's problem-solving skills to today's issues; and the National Park Service, with Rangers Macsali and Boice representing Sarah Olson, superintendent, preserves and interprets the site. The Franklin D. Roosevelt Library, with director Cynthia Koch, guards the historical record. (ERVK.)

THE BRIDGE OVER THE FALLKILL. Eleanor Roosevelt called it her "doorbell." No matter how busy she was or how deeply immersed in thought, the rumble of this bridge over the Fallkill signaled guests, calling her back to the immediate present, this place, and the needs of others. Then, it opened a door to her welcoming smile, attention, wisdom, and help. It remains an open door to an understanding of her legacy and, thus, a bridge to a better world. (NPS.)

ACKNOWLEDGMENTS AND OTHER RESOURCES

The assistance of many individuals and organizations has made this book possible. We acknowledge especially the practical help of husbands, Bill and Tom.

We are immensely grateful for the efforts of Erica Blumenthal, Eileen Hayden, Nancy Fogel, Stephanie Mauri, and David Miles of the Dutchess County Historical Society; Tracy Bocchino, Mona Burchard, Barbara Lindsey, Elayne Seaman, and Margaret Zamierowski of the Eleanor Roosevelt Center at Val-Kill; Cynthia Koch, Karen Anson, Robert Parks, and Alycia Vivona of the Franklin D. Roosevelt Library; Dave Hayes, Tara McGill, Sarah Olson, Franceska Macsali Urbin, and Bill Urbin of the National Park Service; Travis Bowman, Anne Cassidy, Meloyde Moore, Bruce Naramore, and Mary C. Zaremski of the New York State Office of Parks, Recreation and Historic Preservation; and Dean DeMarzo, Margaretta Downey, John Flanagan, Larry Hughes, Kathy McLaughlin, Barry Rothfeld, and Richard Wager of the *Poughkeepsie Journal*.

We especially appreciate the guidance and generosity of John Winthrop Aldrich, James Elliott Lindsley, and Gerald Morgan Jr. for allowing us access to their private collections. We are also grateful to the Franklin and Eleanor Roosevelt Institute for its support.

In addition we thank Elizabeth Tartaglia of the Bardavon Opera House/Hudson Valley Philharmonic Archives; Jane Kellar of Friends of Historic Kingston; Mary R. McTamaney of the Historical Society of Newburgh Bay and the Highlands; Erika Gottfried of New York University, Tamiment Institute Library/Robert F. Wagner Labor Archives; Kathy M. Moyer of Oakwood Friends School; Dean Rogers of Vassar College Libraries Archives and Special Collections; Chris Marinaro of the Westchester County Historical Society; and Linda and Duane Watson of Wilderstein Preservation.

Our sincere thanks also go to those listed below who offered both information and images. Their initials identify them in the credit lines that appear throughout the book:

AC: Anne Core
AI: Armine Isbirian
AR: Albert Rosenblatt
AS: Anne Sutherland
BK: Bernard Kessler
BOH/HVPA: Bardavon Opera House/Hudson
 Valley Philharmonic Archives
BR: Betty Reed
BV: Brenda Verbeck
CSCC: Catharine Street Community Center
CSP: Charles Sylvester Piersaull Collection
DA: Doris Adams
DCHS: Dutchess County Historical Society
DM: Don Marchese
DMW: Doris Muller Wheeler
Edna Gurewitsch
ERVK: Eleanor Roosevelt Center at Val-Kill
F&JM: Frank and Janet Marchese
FDRL: Franklin D. Roosevelt Library
FF: Florence Fried
FG: Fredrica Goodman
FOHK: Friends of Historic Kingston

GMC: George McCornac
GMJr: Gerald Morgan Jr.
GR: Geraldine Rosell
GRS: Gerry Raker Schrier
HL: Hazel Lepore
HSNB&H: Historical Society of Newburgh
 Bay and the Highlands
J&GG: John and Gloria Golden
J&MS: James and Marguerite Spratt
JD: Jerome Deyo
JEL: James Elliott Lindsley
JF: John Flanagan
JG: Joyce Ghee
JMK: Jean McClure Kirchner
JS: Joan Spence
KRT: Kenneth R. Toole
LH: Leslie Hyde
LW: LaClaire Wood
LZ: Lilli Zimet
MC: Maureen Corr
NA: Nancy Alden
ND: Nancy Dubner

NF: Nancy Fogel
NL: Dr. Nathan Lieberman
NPS: National Park Service
NRG: Nina Roosevelt Gibson
NRI: Nancy Roosevelt Ireland
NYSOPR&HP: New York State Office of
 Parks, Recreation and Historic
 Preservation, Clermont Historic Site
NYURFWLA: New York University Robert F.
 Wagner Labor Archives
NYUTIL: New York University Tamiment
 Institute Library
OFS: Oakwood Friends School
PC: Patsy Costello
PD/AS: Paul Didisheim/Ann Segy
PJ: Poughkeepsie Journal
PND: Patricia Niles Dohrenwend
RA: Ralph Arlyck
RC: Rokeby Collection

RHG: Robin Hughes-Ghee
RP: Robert Piggott
RR: Richard Reitano
RS: Ruth Shulman
RV: Ralph Vinchiarello
RW: Richard Wager
SC: Sue Ciani
SCS: Sue Coons Strom
SR: Stephen Rosenfeld
SVJ: Shirley Vaughn Jackson
THC: Thomas H. Cooper
VC: Vassar College Libraries, Archives and
 Special Collections
W&DC: Walter and Doris Cohen
WB: William Brown
WCHS: Westchester County Historical
 Society
WP: Wilderstein Preservation
WW: World Wide

Finally, we would like to thank those who provided information: Claudia Archimede, Maurine Beasley, Allida Black, Marilyn Brown, Bronson Chanler, Cora Mallory-Davis, Paul Draiss, Estelle and Alfonso, directors of the Mid-Hudson Ballet Company, Linda Faber, William Johnston, C. Raymond LaFever, Judith "Kip" Bleakley O'Neill, Lea Osborne of the Junior League of New York City, Keith Olson, Jane Plakias, Bill Rhoads, Mike Risinit, Curtis Roosevelt, Marion Sarles, Eleanor Roosevelt Seagraves, Marie Straub, Sally Sypher of Putman County Records Center, Patricia Wager Weber, and H. Budd Younghanse.

OTHER BOOKS

Beasley, Maurine H., Holly C. Shulman and Henry B. Beasley, ed. *The Eleanor Roosevelt Encyclopedia*. Provides useful information about Eleanor Roosevelt, simply and succinctly and includes a helpful entry on books by and about her. Westport, CT: Greenwood Press, 2001.

Lash, Joseph P. *Eleanor and Franklin*. The Story of Their Relationship Based on Eleanor Roosevelt's Private Papers. New York: W. W. Norton & Company, 1971. Introduced Eleanor Roosevelt to a new generation.

Lash, Joseph P. *Eleanor: The Years Alone* Helpful in gaining an understanding of Eleanor Roosevelt. New York: W. W. Norton & Company, 1972.

Roosevelt, Eleanor. *The Autobiography of Eleanor Roosevelt*. New York, Hagerstown, San Francisco, London: Harper & Row, Publishers, 1961. Abbreviated and augmented version of her autobiography, which had appeared in three volumes: *This Is My Story*, *This I Remember*, and *On My Own*.

Roosevelt, Eleanor II. *With Love Aunt Eleanor, Stories from My Life with the First Lady of the World*. Petaluma, California: Scrapbook Press, 2004. A charming, thoughtful account of Eleanor Roosevelt's life from the perspective of her niece.

Seagraves, Eleanor R., ed and comp. *The Val-Kill Cookbook*. Illustrated by Eleanor Roosevelt Wotkyns, with photographs courtesy of the Franklin D. Roosevelt Library.

WEB SITES

Franklin D. Roosevelt Library and Museum, www.fdrlib.marist.edu.
Eleanor Roosevelt Center at Val-Kill, www.ervk.org.
National Park Service, www.nps.gov.
Poughkeepsie Journal, www.poughkeepsiejournal.com.

ACKNOWLEDGMENTS AND OTHER RESOURCES

The assistance of many individuals and organizations has made this book possible. We acknowledge especially the practical help of husbands, Bill and Tom.

We are immensely grateful for the efforts of Erica Blumenthal, Eileen Hayden, Nancy Fogel, Stephanie Mauri, and David Miles of the Dutchess County Historical Society; Tracy Bocchino, Mona Burchard, Barbara Lindsey, Elayne Seaman, and Margaret Zamierowski of the Eleanor Roosevelt Center at Val-Kill; Cynthia Koch, Karen Anson, Robert Parks, and Alycia Vivona of the Franklin D. Roosevelt Library; Dave Hayes, Tara McGill, Sarah Olson, Franceska Macsali Urbin, and Bill Urbin of the National Park Service; Travis Bowman, Anne Cassidy, Meloyde Moore, Bruce Naramore, and Mary C. Zaremski of the New York State Office of Parks, Recreation and Historic Preservation; and Dean DeMarzo, Margaretta Downey, John Flanagan, Larry Hughes, Kathy McLaughlin, Barry Rothfeld, and Richard Wager of the *Poughkeepsie Journal*.

We especially appreciate the guidance and generosity of John Winthrop Aldrich, James Elliott Lindsley, and Gerald Morgan Jr. for allowing us access to their private collections. We are also grateful to the Franklin and Eleanor Roosevelt Institute for its support.

In addition we thank Elizabeth Tartaglia of the Bardavon Opera House/Hudson Valley Philharmonic Archives; Jane Kellar of Friends of Historic Kingston; Mary R. McTamaney of the Historical Society of Newburgh Bay and the Highlands; Erika Gottfried of New York University, Tamiment Institute Library/Robert F. Wagner Labor Archives; Kathy M. Moyer of Oakwood Friends School; Dean Rogers of Vassar College Libraries Archives and Special Collections; Chris Marinaro of the Westchester County Historical Society; and Linda and Duane Watson of Wilderstein Preservation.

Our sincere thanks also go to those listed below who offered both information and images. Their initials identify them in the credit lines that appear throughout the book:

AC: Anne Core
AI: Armine Isbirian
AR: Albert Rosenblatt
AS: Anne Sutherland
BK: Bernard Kessler
BOH/HVPA: Bardavon Opera House/Hudson Valley Philharmonic Archives
BR: Betty Reed
BV: Brenda Verbeck
CSCC: Catharine Street Community Center
CSP: Charles Sylvester Piersaull Collection
DA: Doris Adams
DCHS: Dutchess County Historical Society
DM: Don Marchese
DMW: Doris Muller Wheeler
Edna Gurewitsch
ERVK: Eleanor Roosevelt Center at Val-Kill
F&JM: Frank and Janet Marchese
FDRL: Franklin D. Roosevelt Library
FF: Florence Fried
FG: Fredrica Goodman
FOHK: Friends of Historic Kingston

GMC: George McCornac
GMJr: Gerald Morgan Jr.
GR: Geraldine Rosell
GRS: Gerry Raker Schrier
HL: Hazel Lepore
HSNB&H: Historical Society of Newburgh Bay and the Highlands
J&GG: John and Gloria Golden
J&MS: James and Marguerite Spratt
JD: Jerome Deyo
JEL: James Elliott Lindsley
JF: John Flanagan
JG: Joyce Ghee
JMK: Jean McClure Kirchner
JS: Joan Spence
KRT: Kenneth R. Toole
LH: Leslie Hyde
LW: LaClaire Wood
LZ: Lilli Zimet
MC: Maureen Corr
NA: Nancy Alden
ND: Nancy Dubner

NF: Nancy Fogel
NL: Dr. Nathan Lieberman
NPS: National Park Service
NRG: Nina Roosevelt Gibson
NRI: Nancy Roosevelt Ireland
NYSOPR&HP: New York State Office of
 Parks, Recreation and Historic
 Preservation, Clermont Historic Site
NYURFWLA: New York University Robert F.
 Wagner Labor Archives
NYUTIL: New York University Tamiment
 Institute Library
OFS: Oakwood Friends School
PC: Patsy Costello
PD/AS: Paul Didisheim/Ann Segy
PJ: Poughkeepsie Journal
PND: Patricia Niles Dohrenwend
RA: Ralph Arlyck
RC: Rokeby Collection

RHG: Robin Hughes-Ghee
RP: Robert Piggott
RR: Richard Reitano
RS: Ruth Shulman
RV: Ralph Vinchiarello
RW: Richard Wager
SC: Sue Ciani
SCS: Sue Coons Strom
SR: Stephen Rosenfeld
SVJ: Shirley Vaughn Jackson
THC: Thomas H. Cooper
VC: Vassar College Libraries, Archives and
 Special Collections
W&DC: Walter and Doris Cohen
WB: William Brown
WCHS: Westchester County Historical
 Society
WP: Wilderstein Preservation
WW: World Wide

Finally, we would like to thank those who provided information: Claudia Archimede, Maurine Beasley, Allida Black, Marilyn Brown, Bronson Chanler, Cora Mallory-Davis, Paul Draiss, Estelle and Alfonso, directors of the Mid-Hudson Ballet Company, Linda Faber, William Johnston, C. Raymond LaFever, Judith "Kip" Bleakley O'Neill, Lea Osborne of the Junior League of New York City, Keith Olson, Jane Plakias, Bill Rhoads, Mike Risinit, Curtis Roosevelt, Marion Sarles, Eleanor Roosevelt Seagraves, Marie Straub, Sally Sypher of Putman County Records Center, Patricia Wager Weber, and H. Budd Younghanse.

OTHER BOOKS

Beasley, Maurine H., Holly C. Shulman and Henry B. Beasley, ed. *The Eleanor Roosevelt Encyclopedia*. Provides useful information about Eleanor Roosevelt, simply and succinctly and includes a helpful entry on books by and about her. Westport, CT: Greenwood Press, 2001.

Lash, Joseph P. *Eleanor and Franklin*. The Story of Their Relationship Based on Eleanor Roosevelt's Private Papers. New York: W. W. Norton & Company, 1971. Introduced Eleanor Roosevelt to a new generation.

Lash, Joseph P. *Eleanor: The Years Alone* Helpful in gaining an understanding of Eleanor Roosevelt. New York: W. W. Norton & Company, 1972.

Roosevelt, Eleanor. *The Autobiography of Eleanor Roosevelt*. New York, Hagerstown, San Francisco, London: Harper & Row, Publishers, 1961. Abbreviated and augmented version of her autobiography, which had appeared in three volumes: *This Is My Story*, *This I Remember*, and *On My Own*.

Roosevelt, Eleanor II. *With Love Aunt Eleanor, Stories from My Life with the First Lady of the World*. Petaluma, California: Scrapbook Press, 2004. A charming, thoughtful account of Eleanor Roosevelt's life from the perspective of her niece.

Seagraves, Eleanor R., ed and comp. *The Val-Kill Cookbook*. Illustrated by Eleanor Roosevelt Wotkyns, with photographs courtesy of the Franklin D. Roosevelt Library.

WEB SITES

Franklin D. Roosevelt Library and Museum, www.fdrlib.marist.edu.
Eleanor Roosevelt Center at Val-Kill, www.ervk.org.
National Park Service, www.nps.gov.
Poughkeepsie Journal, www.poughkeepsiejournal.com.